CÉZANNE

IN PHILADELPHIA COLLECTIONS

THIS CATALOGUE AND EXHIBITION

WERE SUPPORTED BY GRANTS FROM

THE PEW MEMORIAL TRUST

AND THE

NATIONAL ENDOWMENT FOR THE ARTS, A FEDERAL AGENCY

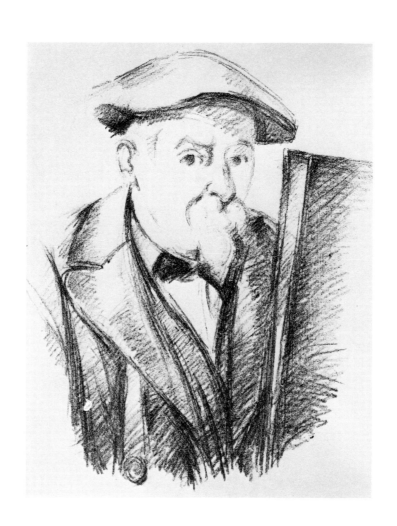

CÉZANNE

IN PHILADELPHIA COLLECTIONS

BY JOSEPH J. RISHEL

PHILADELPHIA MUSEUM OF ART

Distributed by the University of Pennsylvania Press

This book is published in conjunction
with an exhibition at the Philadelphia Museum of Art,
June 19 to August 21, 1983

COVER: *The Large Bathers* (detail), no. 22

FRONTISPIECE: *Self-Portrait,* no. 40

Designed by Joseph B. Del Valle
Printed by Lebanon Valley Offset, Annville, Pa.

Copyright 1983 Philadelphia Museum of Art
Printed in the United States of America
All rights reserved

Photography by Will Brown: nos. 5, 6, 7, 8, 14, 15, 16, 30;
all other works in the exhibition photographed by Eric Mitchell.
Fig. 33a from Léon Deshairs, *Aix-en-Provence: Architecture et
décoration aux dix-septième et dix-huitième siècles* (Paris, 1909), pl. 6.

ISBN 0-8122-7903-4 (hardcover)
ISBN 0-8122-1157-X (paperback)

Distributed by the University of Pennsylvania Press
3933 Walnut Street
Philadelphia, PA 19104

PREFACE VII

CÉZANNE AND COLLECTING IN PHILADELPHIA IX

CHRONOLOGY XX

BIBLIOGRAPHICAL ABBREVIATIONS XXIII

PAINTINGS I

DRAWINGS & WATERCOLORS 49

PRINTS 79

CÉZANNE
IN
PHILADELPHIA COLLECTIONS

Preface

THE CITY OF Philadelphia and its surrounding area are fortunate indeed in their
great holdings of works by French masters of the late nineteenth century. An
impressive number of Philadelphia's artists and collectors were attracted to
advanced painting in France by the first decade of this century, and their
enthusiasm is reflected in both the Museum's holdings and private collections
nearby. The Barnes Foundation in Merion, Pennsylvania, presents the paintings
of Renoir, Seurat, and Cézanne in extraordinary richness, within a vast collec-
tion of the period. Paintings and watercolors by Cézanne on view in the Barnes
Foundation number some sixty-six; if that number is added to the forty-four
works included in the present exhibition, the preeminence of Philadelphia as a
resource for the study of Cézanne becomes undeniable. That this complex,
demanding art should be represented in the city in such quantity is a tribute to
the determination of several generations of Philadelphians to take on the new,
to learn from it, and to live with it day by day. That private collectors should
part with their paintings and drawings for several months so that they can be
shown together with the Museum's holdings prompts renewed appreciation.

In a Museum that rejoices in outstanding works by painters in the great
French tradition, Cézanne's *Large Bathers,* purchased in 1937, continues to prove
the most pivotal work. From its serene and classical balance, we look back at
The Birth of Venus by Poussin, one of Cézanne's acknowledged masters. In the
strangely new, flattened space, large scale, and broadly drawn figures of the
Bathers, we may also find antecedents of the bold, late Cubist ventures of
Picasso's *Three Musicians* and Léger's *The City.*

The initial idea for this exhibition came from the Museum's previous
Director, Jean Sutherland Boggs, and was taken up with customary alacrity
and thoughtfulness by Joseph Rishel, Curator of European Painting before
1900. The preparation of this catalogue would not have been possible without
the most generous assistance of John Rewald, the distinguished scholar whose
knowledge of Cézanne and whose sensitivity to his art are without peer.
Professor Rewald has made available his notes and the files he has assembled
for his catalogue raisonné of Cézanne's paintings and watercolors, the publica-
tion of which, now long anticipated, will set the complicated record straight for
the future. His proposed chronology has been followed throughout. Professor
Rewald and his staff have been extremely gracious in searching out photographs
and providing locations of certain works, as well as discussing objects in this
exhibition. Any errors, however, whether factual or interpretive, are our
responsibility.

Much of the information provided here has emerged from the thorough
examinations carried out by the Museum's Conservation Department, thanks

to the work of Head Conservator Marigene Butler and her staff: particular recognition should go to Mark Tucker, Associate Conservator of Painting, Denise Thomas, Associate Conservator of Works on Paper, and Joseph Mikuliak, Conservation Photographer. All of the works in the Museum's collection, as well as several belonging to private lenders, have been studied in detail, and six have been cleaned and treated in preparation for the exhibition. We are therefore able to present the work of this remarkable artist with renewed freshness and clarity, as well as to bring new physical evidence to bear on the discussion of several issues (*see,* for example, nos. 9 and 10).

The production of the catalogue involved the cooperative efforts of many. The Publications Department responded to an extremely tight editorial schedule with grace and patience. Eric Mitchell and Will Brown produced fine color photography, and Joseph B. Del Valle brought the book together with his characteristic elegance of design. Alice Lefton, of the Department of European Painting, coped valiantly with typing and, aided by Katie Butler, supervised the massive sorting out of bibliography.

This project would not have been possible without the generous support of grants from the National Endowment for the Arts and The Pew Memorial Trust. As an exhibition and a catalogue that focus on the Museum's permanent collection, while simultaneously exploring the remarkable artistic resources of the Philadelphia area, *Cézanne in Philadelphia Collections* may serve as a reminder of the degree to which this city thrives as an international center for the enjoyment of all the arts.

Anne d'Harnoncourt
The George D. Widener Director

CÉZANNE
AND
COLLECTING IN PHILADELPHIA

PHILADELPHIA is a pilgrimage site for anyone seriously interested in Cézanne.[1] In the pattern of taste and collecting, Cézanne is to Philadelphia as Monet is to Boston, yet whereas the Bostonians' appetite for Monet can be explained quite clearly,[2] Cézanne's appeal for Philadelphians still requires explanation. In some cases, the facts are clear, in others, we can but speculate, albeit with some objectivity; while in several instances, one can only go on private instincts concerning individual tastes and motivations.

As with almost any consideration of the awareness of nineteenth-century French painting in Philadelphia, one's first instinct is to turn to Mary Cassatt, whose persistent efforts to engage members of her powerful family in acquiring the works of those artists about whom she felt strongly—Courbet, Degas, Manet, and Monet—established an early pattern of collecting in this city. Even though Mary Cassatt owned a painting by Cézanne (which she eventually sold to buy a Courbet[3]) and knew well several of those artists from the Impressionist group closest to him, she did not meet him until the fall of 1894, at Monet's house in Giverny (*see* no. 18), and there is no evidence that a Cézanne ever entered the collection of any member of her family. Cassatt's first, vivid impressions of the artist are described in a letter to an American friend, Mrs. James Stillman:

> The circle has been increased by a celebrity in the person of the first impressionist, Monsieur Cézanne—*the inventor of impressionism,* as Madame D. calls him.... Monsieur Cézanne is from Provence and is like the man from the Midi whom Daudet describes: "When I first saw him I thought he looked like a cutthroat with large red eyeballs standing out from his head in a most ferocious manner, a rather fiercelooking pointed beard, quite gray, and an excited way of talking that positively made the dishes rattle." I found later on that I had misjudged his appearance, for far from being fierce or a cutthroat, he has the gentlest nature possible, *"comme un enfant"* as he would say. His manners at first rather startled me—he scrapes his soup plate, then lifts it and pours the remaining drops in the spoon; he even takes his chop in his fingers and pulls the meat from the bone. He eats with his knife and accompanies every gesture, every movement of his hand, with that implement, which he grasps firmly when he commences his meal and never puts down until he leaves the table. Yet in spite of the total disregard of the dictionary of manners, he shows a politeness towards us which no other man here would have shown. He will not allow Louise to serve him before us in the usual order of succession at the table; he is even deferential to that stupid maid, and he pulls off the old tam-o'-shanter, which he wears to protect his bald head, when he enters the room. I am gradually learning that appearances are not to be relied upon over here.[4]

Cassatt's enthusiasm for Cézanne, albeit limited, may have been of some inspiration to Louisine Havemeyer in New York, who owned at least five impressive Cézanne paintings; however, it seems more likely that Mrs. Havemeyer was

governed more by her own taste and bought the paintings directly from the Paris dealer Durand-Ruel.

It was only well after the turn of the century that the spark of interest in Cézanne caught on here, and then it came not from New York—where several dealers devoted to modernism were encouraging enlightened patrons such as John Quinn to buy Cézanne—but directly from Paris. In 1912 the painter William Glackens was sent to Paris by Dr. Albert Barnes, the Argyrol mogul of Merion, Pennsylvania, with twenty thousand dollars to buy works of art. It must have been a disappointing visit with regard to Cézanne, however, as Glackens wrote to his wife: "I have been through all the dealers places and have discovered that Mr. Barnes [sic] will not get as much for his money as he expects. You can't touch a Cézanne for under $3000 and that for a little landscape. His portraits and important pictures range from $7000 to $30,000."[5] The implication is that Glackens had set off at Barnes's behest with Cézanne near the top of his list. A more revealing note appears in another letter to his wife sent earlier that week, on his first day in Paris: "I am to meet Alfy [Alfred Maurer, another American artist then living in Paris]…and he is going to introduce me to a Mr. Stein, a man who collects Renoirs, Matisse, etc."[6] What goes unsaid, of course, is that Leo Stein, then living with his sister Gertrude at the rue de Fleurus, was also one of the strongest early advocates of Cézanne, particularly influential with his American friends and visitors. Of the six works by Cézanne that he owned, all eventually found their way into American collections, one to Barnes (Venturi 1087).

Barnes's relationship with Stein was long and tortuous. They had remarkably similar interests, a major passion for Cézanne, Renoir, and Matisse, and a strong interest in Picasso, which turned to disappointment with the advent of Cubism. They were both also deeply interested in psychology and aesthetics and as late as 1934 Barnes sent Stein a copy of *Art as Experience* by Barnes's great friend John Dewey (which Stein deplored). Much to Stein's amazement, Barnes had dedicated his own book on Matisse to him the previous year.[7] To what degree Stein, or for that matter, Glackens actually guided Barnes's initial collecting is unclear.[8] Barnes was notoriously a man of very strong and independent opinions, but the striking parallels between him and Leo Stein do suggest an interrelated series of influences. Barnes stated firmly in an article in 1915 that he owned fourteen works by Cézanne, including the superb portrait of Madame Cézanne (Venturi 528), which he illustrated.[9] Given the date of this publication and the fact that it is unlikely that he would have traveled to Europe during the war, these works must have been acquired between Glackens's visit to Paris in 1912 and the outbreak of war in 1914. Barnes was well launched then, and by the time of the announcement of the establishment of his foundation in 1923, he had acquired some fifty Cézannes.[10] With the possible exception of the Pellerin collection in Paris, his achievement was unprecedented.

Interest in Cézanne in this country came of age during those few years just preceding the First World War: Alfred Stieglitz held his major exhibition of Cézanne watercolors at his "291" gallery in 1911 (with twenty works lent by the Galerie Bernheim-Jeune in Paris),[11] while the inclusion of eight paintings and watercolors in the 1913 Armory Show in New York marked another plateau for the appreciation of the artist.[12] No purchases of Cézanne were made by Philadelphians at these shows; their lasting impact was to be on the American artists themselves, whose own interest in Cézanne would have considerable influence on Philadelphia collecting.

There was another major figure in Philadelphia, however, who had come to terms with the stature of Cézanne: John G. Johnson, the most celebrated and successful lawyer of his day, whose vast collection of paintings, now housed in the Philadelphia Museum of Art, included a small but extremely fine group by the French Impressionists, among them works by Pissarro, Monet, and Degas. At this time he was one of the most powerful members of the board of the Metropolitan Museum of Art in New York and particularly active on the advisory committee for the painting department. Since he was often detained in Philadelphia and could not attend committee meetings, his letters record his opinions with a thoroughness rare in the actual minutes of the meetings. On March 4, 1913, he wrote to Bryson Burroughs, then head of the European painting department: "I regret that I will not be able to get to New York in time to see the exhibition at the Lexington Avenue Armory before it closes. Whilst I would think $8,000 for a Cézanne would be a high price, yet I know you are far better able to judge its commercial and artistic value than I am and if you think the painting at the price is a desirable acquisition I will concur thoroughly in your judgement." Later in the week, he wrote again: "Regret I cannot be present at next meeting owing to an engagement in court. I will be heartily in accord with the purchase of the painting at $6,000 if, in your judgement, it is thoroughly representative and a good example of Cézanne. Whilst the Impressionist art does not appeal very strongly to me, I recognize that this is a mere matter of individual taste and that it does appeal very strongly to very many connoisseurs of the highest taste and best judgement. I think it well, also, for any museum to have represented on its walls examples, as far as possible, of everyone who stands for something in art. Cézanne does thus stand."[13] Certainly this was an enlightened opinion, especially for a man of seventy-two whose taste was very much for earlier painting; he was brave also in supporting without reservation the acquisition of the first Cézanne to enter a public collection in this country. However, Johnson's broad-minded judgment did not carry to the purchase of a Cézanne for himself, nor did it extend to others with whom he had influence in Philadelphia.

There were other people in Philadelphia who, like Barnes, were very alert to the importance of recent movements in France and to Cézanne's role in them. They were a group of painters, all recent students of the Pennsylvania Academy of the Fine Arts, few in number but energetic and courageous about their convictions: H. Lyman Saÿen, Morton Livingston Schamberg, and Charles Sheeler. In 1908–9, Schamberg and Sheeler were in Paris.[14] They visited Michael Stein, and perhaps also Leo and Gertrude, and returned to Philadelphia with Cézanne very much on their minds. Saÿen had preceded them to Paris, having been sent there in 1906 by Rodman Wanamaker to design and supervise the printing of posters and catalogues for his New York and Philadelphia department stores.[15] There he had met Leo Stein, with whom he seems to have struck up a close friendship (they played billiards together at the Dôme), and he had also enrolled as a student of Matisse.

The influence of these three men on Philadelphia's awareness of French progressive painting in general, and of Cézanne in particular, is hard to gauge, although they all reflected his influence in their own work. The 1913 Armory Show in New York, of course, gave further strength to their convictions and a new edge to their endeavors. In anticipation of the exhibition's opening, Schamberg wrote an article for the Sunday art page of the *Philadelphia Inquirer* in which he lucidly (and prudently, given the anticipation of hostility from his audience) attempted to place

modern painting in some historical perspective: "The art of Cézanne, Matisse, of Picasso, etc., is based upon the same ideas as that of Italy, Greece, Egypt, India, China, Africa or Mexico, in fact, of the art of all the centuries since its first manifestations."[16]

In this, Schamberg must have been speaking not polemically but with considerable conviction. Sheeler, before his Paris visit with Schamberg, had been in Italy, and Piero della Francesca had become a hero, along with the new art they would see in Paris. The culmination of these enthusiasms came in the miniature version of the Armory Show at the McClees Gallery in 1916, boldly entitled "Philadelphia's First Exhibition of Advanced Modern Art,"[17] which Schamberg and Saÿen organized.[18] The thirty-one works represented were primarily left over from the Armory Show; no Cézannes were included. The vigorous, and sometimes naive, convictions with which they continued their push for modernism is indeed touching, and their own paintings carried the battle into new territory. But Philadelphians had a resource unavailable anywhere else in the country: Albert Barnes and his collection. As Saÿen explained patiently to a woman puzzled by the subject of one of his lectures on modern art: "There has been Impressionism, Neo-Impressionism, Renoir, Cezanne, Signac, Seurat, Rousseau the Douanier, Matisse, Picasso and all of the splendid work of the last decade in France.... Of course I understand that these works are almost inaccessible here, but then I must leave that to you. As a suggestion I would advise a visit to the collection of Dr. Albert C. Barnes, Latches Lane, Overbrook, where many of these paintings may be seen."[19]

These young artists brought a spirit of independence and energy to the cause of exposing Philadelphia to modern painting. This, however, was restricted to a limited circle and would be short-lived: Saÿen and Schamberg both died in 1918, and Sheeler moved to New York, more or less permanently, the following year, where through his close connection with Alfred Stieglitz, Marius de Zayas, and Louise and Walter Arensberg, he carried on the progressive movement. He seems, however, to have maintained contact with Barnes: several of the photographs of Barnes's paintings (including the Cézannes) in the 1923 article in *The Arts* announcing the formation of the foundation were taken by Sheeler.[20]

It was really to another quite different group of men, Henry McCarter, Arthur B. Carles, Franklin Watkins, Carroll S. Tyson, Jr., and Adolphe Borie—artists themselves but all more settled into the overall life of the city—that the mantle of thoughtful and responsible support of progressive painting would shift. They were a close group, bonded socially through the most enviable round of parties, long lunches, and other pleasures which the 1920s would afford. They were joined slightly later in their informal camaraderie by R. Sturgis Ingersoll, who by the 1930s would become a major figure in Philadelphia collecting.[21]

McCarter, born in 1864, was a congenial man who provided a link back to Thomas Eakins and Walt Whitman, the only one of this group from an earlier generation. Having lived in Paris in the 1890s, he constituted a connection with the French painters in whom the younger members of this group were developing such a keen interest. He had worked with Toulouse-Lautrec as a lithographer and knew Pissarro quite well; he also had seen the works of Cézanne abroad, as he told Ingersoll: "A great many years ago when I was a student in Paris. Many people spoke of an exhibition of painting at the Georges Petit Gallery. They liked it or hated it and they always showed surprise and some excitement in speaking of it. It was an exhibition of possibly 25 moderately sized canvases.... They were

Cézanne."[22] While it may be assumed that it was the 1895 show at Vollard's gallery that he saw and not one at Georges Petit (Ingersoll notes McCarter's lovable abandonment of both chronology and fact in his anecdotes),[23] here was a man in their midst who had actually been there, and through his own work and his energetic support of the new, he must have been a marvelous catalyst for his friends.

Fired by the Armory Show, Borie, Tyson, Carles, and McCarter organized a show at the Pennsylvania Academy of the Fine Arts in 1920.[24] Once again, they had the example of Barnes and his pictures to reinforce their own art and taste, as Ingersoll noted: "Barnes welcomed us, and there was spread before us the richness of a collection which excels within its field the combination of all public and private collections of Paris."[25] The show would prove to be a public declaration of their own taste and a major platform for the artistic education in this city, where the Armory Show and even its modest offshoot in the McClees Gallery in 1916 had been met with particular ferocity. Called "An Exhibition of Paintings and Drawings by Representative Modern Artists," and by the standards of the Armory Show a rather tame effort, it was intended by its organizers to persuade their audience gently. There were forty-one Cassatts (all drawn from local collections), seventeen Renoirs, and nineteen Manets, interspersed, however, with works by Georges Braque, André Derain, Jacques Villon, Pablo Picasso, and Stanton Mac-Donald-Wright. Fourteen Cézannes were also included, from the collections of Lillie P. Bliss, Marius de Zayas, Walter Arensberg (including the *Still Life with Apples* [no. 3]), and Mrs. Eugene Meyer—eight oils, four watercolors, and two lithographs.

Leopold Stokowski provided the introduction to the catalogue, taking up with his very persuasive bias the purpose of his painter friends in organizing the show:

> It is curious that while the music of Debussy, Strauss, Skryabin, Stravinsky, and Schoenberg is known and accepted in Philadelphia as of great aesthetic value, the paintings of Seurat, Renoir, Cézanne, Dégas, Picasso and Matisse, outside of a few connoisseurs, are unknown or ridiculed.
>
> And yet in the art-centres of Europe it is a received opinion that both the above groups of painters and composers have simultaneously developed in new and often similar directions of deep and lasting significance.
>
> Will Philadelphia realize this? It is important intrinsically, and also because a new school of painters is arising in America which is penetrating still farther in the direction taken by such masters as Cézanne, Picasso and Matisse. It would be a great national loss if these should be unrecognized in their own country.[26]

It is an impressive statement, reflecting the genuine popularist desires of these men to bring their audience out of reactionary and hostile Philistine positions. The degree of their success and failure was perhaps reflected by Peggy Shippen in her "Diary" in the *Philadelphia Public Ledger* on April 25, 1920. After having noted the importance of the event as "one of the most extraordinary loan exhibitions of paintings by modern masters ever brought together in this city," she predictably praises the Cassatts (dwelling on family connections with the city), mentions several other nineteenth-century works (including Cézannes), and then lashes out at the "ultra-modern schools—cubists, futurists and others whose work is more or less incomprehensible to persons of sound minds and normal sight...." Perhaps most discouraging for the organizers in their hope to raise interest locally is her closing comment: "Mr. Victor White, the New York artist, who is in the city to

paint a copy of Chief Justice John Marshall, tells me that quite a number of New York artists are coming on to see the collection. Indeed the latter is creating as much interest in other cities as it has created here—probably more."

However, the group was sufficiently energized by the relative success of their efforts to organize an equally large exhibition at the Academy the following year, "Later Tendencies in Art."[27] In 1923 McCarter and Carles persuaded Barnes to lend a group of contemporary works from his collection to the Academy[28] and the results—great hostility in the press and public confusion—did much to persuade Barnes to restrict access to his collection to those honestly interested in looking at pictures, rather than curiosity seekers. But neither of these shows included Cézanne.

As Sturgis Ingersoll noted in his reminiscence of the 1920 exhibition, it was Carroll Tyson who had "unearthed Cézannes."[29] This remarkable man's devotion to the artist—even exceeding his love of Manet—would have a profound effect on Philadelphia's connection with Cézanne. Tyson, an accomplished painter, first went abroad to study in 1900, at the age of twenty-two.[30] It is unclear exactly when or where his interest in progressive French art began, but he certainly must have been aware of it in Paris. He and his wife seem to have been on good terms with Barnes well into the 1920s, and they were also frequent visitors to, and friends of, Louisine Havemeyer. It was not until he came into some of his inheritance in the mid-1920s, however, that Tyson was able to acquire substantial works by any of the artists he so much admired, and then he did so in a seemingly impulsive and unstructured way. He would in time own eight works by Cézanne, all of them of major importance. In his devotion to quality and collecting in this period, he was certainly encouraged by his friends, among them, Earl Horter, a successful commercial artist who would himself paint in a manner strongly influenced by Cézanne.[31]

Tyson and his friends were deeply interested in the new vitality of the art museum which, under its energetic director, Fiske Kimball, was taking on considerably greater ambition. In the "Inaugural Exhibition," which opened the new museum on Fairmount in 1928, three Cézannes were included in the section reviewing French art: a landscape, a still life, and a portrait of Madame Cézanne.[32] The first two were lent by Mr. and Mrs. Carroll Tyson; the portrait, by Samuel and Vera White. The Whites were much influenced in their collecting by their close friend Dr. Barnes, whose courses they attended; between 1924 and 1928 they bought four works by Cézanne (nos. 2, 13, 29, 31).[33]

Other collectors in Philadelphia were also pursuing Cézanne with considerable energy, the most enigmatic perhaps being Raymond Pitcairn, whose brother Theodore had gathered one of the choicest collections of nineteenth-century French art in the country. Raymond, whose great passion was medieval objects and glass, did purchase out of the Quinn estate Cézanne's great early *Portrait of the Artist's Father,* but it seems to have been his only venture in this area.[34]

Tyson joined the standing Committee on Museum at the Pennsylvania Museum of Art in December 1933, and certainly his active presence had much to do with the Cézanne exhibition organized there that fall. It contained sixty-three works from American collections, the largest gathering of the artist's works in this country to date.[35] Lionello Venturi observed when he visited the show that it "was exceedingly well organized and in point of numbers probably the most important Cézanne exhibition ever held."[36]

Paul Cézanne
Portrait of Louis-Auguste Cézanne, the Artist's Father, 1860–63
Oil on plaster transferred to canvas
66 x 45″
National Gallery, London

However, as Erle Loran discussed in his review of the exhibition, the enthusiasm for Cézanne stood, at that point, in danger of turning in on itself:

> Has critical opinion of Cézanne already arrived at that intermediate or "morning after the excitement" stage which was bound to come? If so it is here remarkably soon after the discovery stage, and it promises more excitement than we had during the years when every new writer on Cézanne tried to out-rhapsodize his predecessor. During this period, if we are really in it, we are bound to read startling confessions from those who were merely swept along by the turbulent current of enthusiasm, and from those who were so mystified and confounded by the spectacle of Cézanne's overpowering originality that they thought they were really being thrilled by superb painting. Now that the pendulum has begun to swing back, many will not longer be bothered by this madman of Aix and they will find peace. Hordes of simple souls will raise a cry of relief when they read Thomas Craven on these French modernists and Albert Sterner on the "Cézanne Myth." At last the public gets a break and it can say with critical sanction, "I always knew this stuff was the bunk."[37]

Yet the local press was, on the whole, quite favorable, and in one case, genuinely laudatory: Dorothy Grafly, critic for the *Philadelphia Record,* thanked the Museum outright for offering "'an opportunity to study the development of Paul Cézanne, ancestor of thousands of modern painters in virtually all countries of the Western world.'"[38]

The lenders, to gather from correspondence of the time, were quite content, and the director, Fiske Kimball (who himself had sent two color lithographs to the exhibition),[39] could report to the Committee on Museum that the show was "drawing a stream of visitors from other cities and from abroad, who besiege our doors on closed days," and that it "continued its great success to the close....The number of visitors during the 18 open days of the exhibition...was 29,458...."[40] The remarkable thing, in hindsight, was the amazing quality of the loans in what was, despite the thoughtful introduction to the catalogue by Jerome Klein, a rather casually gathered group of objects. As Loran noted in his review, it was an imbalanced selection with too much representation of the middle 1880s (which he found somewhat dull and pedantic), but it nonetheless presented a very substantial group of works.[41] The following year, building on the triumphs of this exhibition and with the support of Henry P. McIlhenny (he had joined the staff in January 1935), Kimball encouraged a broader, survey show of Post-Impressionism, which included six Cézannes, to celebrate the opening of the French galleries in the Museum.[42]

Thus, by the mid-1930s, the Museum had begun to show French progressive painting with a vigor rare in this country, yet there was still no Cézanne in the permanent collection. It was a great compliment to Kimball and Tyson as well as to the remarkably sophisticated young staff who had gathered around them during the Depression that, when a substantial sum became available in 1936 as the result of endowed funds from the Elkins family, there was no disagreement that a major Cézanne be given first priority for acquisition. Various scouts were sent out, and the pictures shown at the Museum in the exhibitions of 1934 and 1935 were reviewed. The works then available for consideration were remarkable in their quality and importance. Among those seriously discussed were *The Black Clock* (then with Wildenstein, New York; Venturi 69), *The Abduction* (with Marie

Harriman Gallery, New York; Venturi 101), *The Château Noir* (with Paul Rosenberg, Paris; Venturi 794), *The Climbing Road* (with Wildenstein, New York; Venturi 333), *The House at Bellevue* (with Paul Rosenberg, Paris; Venturi 655), and *Mont Sainte-Victoire* (with Paul Rosenberg, Paris; Venturi 798).[43] *The Château Noir* had already been committed to the Cézanne exhibition being organized by Charles Sterling at the Musée de l'Orangerie in Paris.[44] This show, which in its scale and breadth of presentation marked the coming of age of Cézanne for a broad international audience, served the Philadelphia search committee very well. On Kimball's behest, Henry McIlhenny went to Paris to survey the selection (his own *Madame Cézanne* [no. 15] was one of the loans), and cabled back on June 12, 1936: "Victoire much greater than Château Noir. No mistake to purchase."[45] The final selection came down to this landscape and *The House at Bellevue*.

The committee's comments are revealing as to the depth of their thoughts on the subject and the security of their opinions. Louise Elkins Sinkler, daughter of the donor of the funds through which the picture would be acquired, wrote to Museum president J. Stogdell Stokes on June 12, 1936: "I stopped in at the Museum to see the Cezanne landscape which is being considered as an addition for my father's collection. I think it is a magnificent example of Cezanne's art, and doubly valuable to the Museum, as it cannot now boast one. I refer to the blue picture with the mountain—the other does not appeal to me."[46] Carroll Tyson, writing from Maine, regretted that he could not be there for the vote (as he had been deeply involved in the original discussions): "Two Cezannes of that importance—one couldn't very well go wrong—... The Wildenstein one I thought that the 'Public' might understand better—but the 'Public' can be educated to the other just as well!"[47]

And Arthur Carles summed up his reactions: "The Mountain, which I have just seen in your office, is one of the most remarkable Cézannes I have ever seen. He seems to have accomplished in one stroke what he had been struggling for over a long period of years. It must have been a sudden transition for him, and while some of the subtleties of the early struggles seem absent, the completeness of the whole is so powerful as to leave all doubts aside as to its being one of his greatest masterpieces."[48] The committee voted unanimously for *Mont Sainte-Victoire;* the price was thirty-six thousand dollars.

The events of the following year proved to be even more remarkable. In January, the Commissioners of Fairmount Park, administering the Wilstach Collection and its endowed acquisition funds, informed the Committee on Museum that the time was probably right to pursue a major acquisition in the realm of European painting. Despite its purchase of a late Cézanne the previous year, the committee did not hesitate to attempt to acquire the *Large Bathers* from the Pellerin collection. Tyson seems to have had visited the collection some years earlier and had remembered the magnitude of the picture with considerable vividness. McIlhenny, on his visit to the 1936 Paris exhibition, had with the rather charming candor of his years noted in his catalogue: "Terribly important—a good picture to purchase," and then large, across the top of the page, "Really a swell thing."[49]

Negotiations were begun with the Pellerin family, Wildenstein acting as agent. The primary dilemma, given the scale of the expenditure, was to gain the support of Joseph Widener, chairman of the Wilstach Collection. Through the inheritance of his father's collection and the very selective additions and deletions he made to it, Widener had become one of the greatest collectors of old masters in the country,

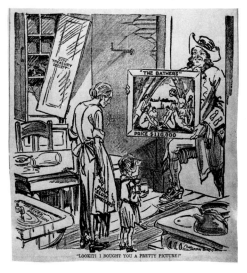

Philadelphia Record, November 13, 1937
"Lookit! I bought you a pretty picture!"
Cartoon by Jerry Doyle

although he was hardly known for his taste for progressive French painters. Carroll Tyson was the committee member elected to visit Widener in Palm Beach, and with considerable diplomacy he persuaded him to agree to the purchase—even though he later confessed that he spent a rather sleepless summer ("What will he do when he sees that figure without any face?").[50] Widener himself was present at the unveiling of the work and announced its purchase, Fiske Kimball having drafted his statement. However, the press release distributed the following day was not received well and the Museum had made one major misstep in the wording: "The acquisition of the Pellerin 'Bathers' gives to Philadelphia and its neighborhood the distinction of owning the two best-known versions of the painter's famous subject. The second version, and a slightly smaller picture, is in the collection of the Barnes Foundation at Merion and was purchased by Dr. Albert C. Barnes from the Vollard collection in 1933."[51] With predictable vehemence, Barnes announced at his own press conference that his was by no means the "second" version and that, in fact, the Museum's new acquisition was—in its unfinished state—an unfair and weak example of the artist's work.[52] The press went wild. Cartoons were published commenting on the situation, and the headline of one article on the purchase read: "Perhaps the 'Bathers' Is All Wet."[53] The affair did subside, although it became apparent that Barnes had been lost entirely to the Museum in this battle. The Museum did not respond to the controversy in any official manner, and it was perhaps with some irony that Kimball reported to the Committee on Museum that on the Sunday after the picture had been unveiled attendance at the Museum had increased dramatically compared to the Sunday before.[54]

These two grand works—*Mont Sainte-Victoire* (no. 20) and the *Large Bathers* (no. 22)—were the only Cézannes that the Museum purchased. But, the daring and progressive outlook of the Museum administration served as a beacon for future gifts and bequests of late nineteenth- and early twentieth-century art, including the collections of Louise and Walter Arensberg, A.E. Gallatin, Louis Stern, Samuel and Vera White, Frank and Alice Osborne, and, most importantly for Cézanne, Mr. and Mrs. Carroll Tyson, whose group of paintings entered the Museum in 1963. And, as will be noted by the private loans included here, it is a pattern which continues: four of the works from private collections have been acquired recently. To what degree this appetite for Cézanne in Philadelphia has a profound logic is still difficult to judge. Certainly the activities of the 1920s and 1930s, both public and private, seem in remarkable harmony with later developments. It is particularly satisfying to note that to celebrate the opening of the 1934 Cézanne exhibition, a luncheon was given in honor of Marcel Duchamp.[55] The receipt of the Arensberg (1950) and Gallatin (1952) collections has made Philadelphia one of the prominent places from which to consider the legacy of Cézanne and his complex impact on the art of our century.

NOTES:

NOTE: In May 1979 John Rewald presented a series of lectures at the National Gallery of Art in Washington, D.C., on the early collecting of Cézanne in this country; he is presently preparing these for publication and he has been particularly generous in discussing the various points that touch on Philadelphia. I am particularly grateful for his thoughts on the possible motivations for Dr. Barnes's interest in Cézanne. I have also relied on the comments made on Philadelphia in the first half of this century by Darrel Sewell in his introduction to Philadelphia, PMA, *Philadelphia: Three Centuries*

of American Art (April 11–October 10, 1976), pp. xx–xxii. The family of Mr. and Mrs. Carroll S. Tyson, Jr., has been particularly generous in discussing the attitudes and interests of these two people who were so critical in bringing major works by Cézanne to this city.

1. The Barnes Foundation, Merion, Pa., has 66 works on view. The majority of these are discussed and illustrated in Barnes, 1939. The collection of the Philadelphia Museum contains 28 paintings, watercolors, and prints, supplemented here by 16 loans from private collections in the area.

2. For a discussion of the collecting of Monet in Boston, *see* Alexandra R. Murphy, "French Paintings in Boston: 1800–1900," pp. xli–xliv, in Atlanta, The High Museum of Art, *Corot to Braque: French Paintings from the Museum of Fine Arts, Boston* (April 21–June 17, 1979).

3. She bought the picture, a still life, for 100 francs and sold it 25 years later for 8,000 francs. *See* Frederick A. Sweet, *Miss Mary Cassatt: Impressionist from Pennsylvania* (Norman, Okla., 1966), p. 195.

4. Quoted in Rewald, 1948, p. 166.

5. February 16, 1912; quoted in Ira Glackens, *William Glackens and the Ashcan Group: The Emergence of Realism in American Art* (New York, 1957), p. 158.

6. February 13, 1912; quoted in *ibid.,* p. 157.

7. *See* Leo Stein, *Journey into the Self,* ed. Edmund Fuller (New York, 1950), pp. 147–51, 136. The work dedicated to Stein is Albert C. Barnes and Violette de Mazia, *The Art of Henri-Matisse* (New York, 1933).

8. The actual dates of Barnes's purchases remain unclear, as does an understanding of the motivations that prompted them. Two biographers have attempted to clarify the pattern, although despite Barnes's own emphasis on the importance of scientific objectivity for aesthetics and collecting, it continues to be difficult to separate facts from emotions. *See* Henry Hart, *Dr. Barnes of Merion: An Appreciation* (New York, 1963); and Gilbert M. Cantor, *The Barnes Foundation: Reality vs. Myth* (Philadelphia, 1963).

9. Albert C. Barnes, "How to Judge a Painting," *Arts and Decoration,* vol. 5, no. 6 (April 1915), p. 219, repro.

10. *See* Forbes Watson, "The Barnes Foundation," *The Arts,* vol. 3, no. 1 (January 1923), p. 13.

11. New York, The Little Galleries of the Photo-Secession, "Exhibition of Twenty Watercolors by Cézanne" (March 1–25, 1911).

12. New York, Association of American Painters and Sculptors, Inc., *International Exhibition of Modern Art* (February 17–March 15, 1913), p. 72. Barnes visited the Armory Show but bought only a painting by Vlaminck. *See* Milton W. Brown, *The Story of the Armory Show* (New York, 1963), p. 312.

13. Johnson to Burroughs, March 1913 (The Metropolitan Museum of Art Archives, New York, no. P 1660). Johnson's particular support of Cézanne must have depended somewhat on his close friendship with Roger Fry, who had been writing enthusiastically about Cézanne since 1906.

14. *See* Ben Wolf, *Morton Livingston Schamberg* (Philadelphia, 1963), pp. 21–22; and Constance Rourke, *Charles Sheeler: Artist in the American Tradition* (New York, 1938), pp. 25–28.

15. *See* Adelyn D. Breeskin, *H. Lyman Saÿen* (Washington, D.C., 1970), p. 34.

16. January 19, 1913; quoted in Wolf, *Schamberg,* p. 27.

17. Philadelphia, McClees Gallery, *Philadelphia's First Exhibition of Advanced Modern Art* (May 17–June 15, 1916).

18. *See* PMA, *Three Centuries,* p. 498.

19. Quoted in Breeskin, *Saÿen,* p. 20.

20. Watson, "Barnes," repros. pp. 11, 15–16, 23, 25. Sheeler photographed works for various dealers, including de Zayas and Montross, in New York, and these photographs may have come through them, or Sheeler may have actually photographed the paintings in Merion.

21. Ingersoll attended the Armory Show at least twice; while he carefully took notes in the catalogue on the colors of each Cézanne on view (his annotated copy is in the PMA Library), he admitted later that the show had little impact on him. He was only 23 then and, as he noted, still very caught up with literary, not visual, interests. *See* R. Sturgis Ingersoll, *Recollections of a Philadelphian at Eighty* (Philadelphia, 1971), pp. 51–52.

22. Quoted in R. Sturgis Ingersoll, *Henry McCarter* (Cambridge, Mass., 1944), p. 27.

23. *Ibid.,* p. 49.

24. Philadelphia, The Pennsylvania Academy of the Fine Arts, *Catalogue of an Exhibition of Paintings and Drawings by Representative Modern Artists* (April 17–May 9, 1920).

25. Ingersoll, *McCarter,* p. 73.

26. Pennsylvania Academy, *Representative Modern Artists,* p. 4.

27. Philadelphia, The Pennsylvania Academy of the Fine Arts, *Exhibition of Paintings and Drawings Showing the Later Tendencies in Art* (April 16–May 15, 1921).

28. Philadelphia, The Pennsylvania Academy of the Fine Arts, *Catalogue of an Exhibition of Contemporary European Paintings and Sculpture* (April 11–May 9, 1923).

29. Ingersoll, *McCarter,* p. 73.

30. *See* Louis C. Madeira IV, "Homage," in New York, Hirschl & Adler Galleries, Inc., *Carroll S. Tyson, 1878–1956: A Retrospective Exhibition* (October 15–November 9, 1974).

31. *See* PMA, *Three Centuries,* p. 523.

32. "The New Museum of Art Inaugural Exhibition," *The Pennsylvania Museum Bulletin,* vol. 23, no. 119 (March 1928), p. 15.

33. The Whites were also close friends of Arthur Carles. *See The Samuel S. White, 3rd, and Vera White Collection, Philadelphia Museum of Art Bulletin,* vol. 63, nos. 296–97 (January–March and April–June 1968), pp. 76–77, 90, nos. 13–14, p. 104, nos. 51–52.

34. This picture was frequently on loan to the Museum from 1931 until Raymond Pitcairn's death in 1966. He had purchased it from the estate of John Quinn in 1924. *See* Washington, D.C., Hirshhorn Museum and Sculpture Garden, *"The Noble Buyer:" John Quinn, Patron of the Avant-Garde* (June 15–September 4, 1978), p. 153.

35. *See* Philadelphia, 1934.

36. Quoted in Laurie Eglington, "Dr. Venturi Gives Lively Interview on Recent Visit," *The Art News,* vol. 33, no. 14 (January 5, 1935), p. 4. Venturi, who then was preparing his catalogue raisonné (*see* Venturi, 1936), also noted the great convenience of having so many American pictures gathered in one place.

37. Erle Loran, "Cézanne at the Pennsylvania Museum," *The American Magazine of Art,* vol. 28, no. 2 (February 1935), p. 85.

38. Quoted in "64 Cezannes, Owned in America, in Exhibition," *The Art Digest,* vol. 9, no. 5 (December 1, 1934), p. 6.

39. *See* no. 44; and Philadelphia, 1934, no. 59.

40. "Committees—Minutes and Reports," November 26, 1934, and December 17, 1934, BT, series 3, PMA Archives.

41. Loran, "Cézanne," p. 85.

42. "The Post-Impressionists, February 2–March 13, 1935," EXH, PMA Archives.

43. *See ibid.;* "Cézanne, November 10–December 10, 1934," EXH; and "Cézanne, La Montagne Sainte-Victoire, 1936," FKR, series 4 (all PMA Archives); and I.P. Records, 1936/37, Registrar's Office, PMA.

44. Paris, 1936, p. 126, no. 111, pl. 30.

45. "Cézanne, La Montagne Sainte-Victoire, 1936," FKR, series 4, PMA Archives.

46. *Ibid.*

47. Tyson to Kimball, June 12, 1936, in *ibid.* The "Wildenstein one" refers to *The Climbing Road,* in which Tyson was particularly interested.

48. Carles to Kimball, June 12, 1936, in *ibid.*

49. The PMA Library has McIlhenny's annotated copy of Paris, 1936.

50. "The *Grandes Baigneuses,*" FKP, series 6: SSC, PMA Archives. The Museum's pursuit of the *Large Bathers* and Joseph Widener's part in the purchase is reviewed, using Kimball's papers and their own memories of the event, by George and Mary Roberts in *Triumph on Fairmount: Fiske Kimball and the Philadelphia Museum of Art* (Philadelphia, 1959), p. 182.

51. "Cézanne's 'Bathers' Bought for Museum on Phila. Parkway at Cost of $110,000," *Philadelphia Evening Ledger,* November 10, 1937.

52. *See* "City 'Stung' on Cezanne Art, Collector Barnes Declares," *Philadelphia Inquirer,* November 16, 1937. Barnes continued his criticism in a pamphlet he published on January 3, 1938, entitled "A Disgrace to Philadelphia." He would expand on his opinions in his analysis of the picture in Barnes, 1939, pp. 391–93.

53. *Philadelphia Inquirer,* November 17, 1937.

54. "Committees—Minutes and Reports," November 22, 1937, BT, series 3, PMA Archives.

55. *See* Ingersoll, *McCarter,* p. 87.

CHRONOLOGY

1839 Born January 19 in Aix-en-Provence; his father Louis-Auguste Cézanne, a successful manufacturer of hats, would, in 1848, acquire the only bank in the city; two sisters, Marie and Rose, born 1841 and 1855, respectively.

1844–52 Attends school in Aix.

1852–58 Attends the Collège Bourbon in Aix, where he establishes a close friendship with Emile Zola.

1858–59 Studies drawing at the Ecole des Beaux-Arts in Aix.

1859–60 At his father's insistence, begins law studies at the university of Aix, but continues to study at the Ecole des Beaux-Arts; his father acquires a large eighteenth-century house, the Jas de Bouffan, on the outskirts of the city.

1861 Abandons law studies and with the reluctant approval of his father, joins Zola in Paris (April–September); fails to pass entrance examinations for the Ecole des Beaux-Arts; meets Pissarro at the Atelier Suisse; in the fall, joins father's bank in Aix.

1862–64 Leaves the bank and returns to Paris; through Pissarro and the painter Armand Guillaumin, meets Sisley and Monet; first of numerous rejections by Salon jury (1864); copies Delacroix at Musée du Luxembourg.

1865–68 Establishes restless pattern of moves between Paris and Aix; in Paris (1865), petitions the Superintendent of Fine Arts, the comte de Nieuwerkerke, to reestablish the Salon des Refusées.

1869 Meets Hortense Fiquet (born 1850) in Paris.

1870 During Franco-Prussian War, returns to the South, establishing Hortense at L'Estaque.

1871 Returns to Paris.

1872 Birth of his son Paul; moves with family to Pontoise, where he sees much of Pissarro and Guillaumin.

1873 Moves with family to the house of Doctor Gachet in Auvers-sur-Oise, near Pontoise.

1874 Exhibits three pictures in the first Impressionist exhibition at Nadar's studio in Paris.

1875 Victor Chocquet buys a Cézanne painting from the dealer Père Tanguy.

1876 Works at Aix and L'Estaque in the spring and summer.

1877 Exhibits sixteen works in the third Impressionist exhibition.

1878 Works at L'Estaque the entire year.

1879 Continues to work at L'Estaque, but returns north in March.

1880–81 Works primarily in and around Paris.

1882 At L'Estaque (where he is visited by Renoir), then in Paris and with Zola in Médan, on the Seine.

1883–84 In the South at Aix and L'Estaque; strikes up friendship with the painter Adolphe Monticelli.

1885 Mostly in the South; short visit with Hortense and Paul to Renoir at Roche-Guyon on the Seine near Giverny; begins working at Gardanne, near Aix.

1886 Spends most of year at Gardanne; Zola publishes L'Oeuvre, whose major character is based on Cézanne, causing a break between the two friends; April 28, marries Hortense in the presence of his parents; October 23, his father dies at the age of eighty-eight; Cézanne comes into a sizable fortune, but does not change his simple manner of life.

1887 Primarily in the South; rents a small room at the Château Noir to store his painting equipment, and continues to work in this area off and on until 1902.

1888 In Aix, and then in Paris; works at Chantilly and along the Marne.

1889 Roger Marx insists that the House of the Hanged Man (Venturi 133) be shown at the Exposition Universelle.

1890 Exhibits three paintings with the group known as "Les XX" in Brussels; spends five months in Switzerland (his only visit outside France) with his wife and son.

1891 Remains in Aix until the fall; forces his wife and son to move there from Paris.

1892 Works in Aix and Paris and in the forest at Fontainebleau; Georges Lecomte and Emile Bernard publish positive criticism of his work.

1893 Works in Aix, Paris, and Fontainebleau.

1894 Primarily in Paris; visits Monet at Giverny in September.

1895 In Paris and Aix, where he rents a hut in the quarry of Bibémus; in November the dealer Ambroise Vollard holds an exhibition of more than one hundred paintings and watercolors in Paris.

1896 The State rejects three of the five Cézanne paintings left to the nation through the Caillebotte bequest (announced publicly in 1894); in Aix, Paris, and briefly in the east of France at Vichy and Lac d'Annecy.

1897 In Paris and Aix; abandons the Jas de Bouffan after the death of his mother in October.

1898 Vollard holds a second Cézanne exhibition; final prolonged stay in Paris.

1899 Exhibits at the Salon des Indépendants; sells the Jas de Bouffan and moves to an apartment in the city; Vollard holds a third exhibition.

1900 Exhibits three works at the Exposition Universelle Centennale; Maurice Denis (who had not yet met Cézanne) paints his *Hommage à Cézanne.*

1901 Submits works to the Salon des Indépendants and to the Salon de la Libre Esthétique in Brussels.

1902 Installs himself in the newly completed studio at Les Lauves, just north of Aix.

1903 Represented in exhibitions in Berlin and Vienna; sale of ten early works from the estate of Zola (died 1902) prompts a violent attack against Cézanne in the press.

1904 Emile Bernard arrives in Aix and strikes up a warm friendship with Cézanne; shows ten works in Brussels; thirty paintings and ten drawings given their own room at the Salon d'Automne in Paris.

1905 His growing reputation prompts a number of young painters to visit him in Aix.

1906 Denis and the painter K.-X. Roussel travel to Aix in January, and the German collector Karl Ernst Osthaus visits him in April; October 15, collapses after being caught in a storm while working out of doors; dies October 22.

1907 Fifty-six major works, including several from the collection of Auguste Pellerin, shown at a memorial exhibition at the Salon d'Automne in Paris.

BIBLIOGRAPHICAL ABBREVIATIONS

Barnes, 1939
Albert C. Barnes and Violette de Mazia. *The Art of Cézanne.* New York, 1939.

Brion, 1974
Marcel Brion. *Cézanne.* Garden City, N.Y., 1974.

Cézanne, 1941
Paul Cézanne. *Paul Cézanne: Letters.* Edited by John Rewald. London, 1941.

Chappuis, 1973, or Chappuis
Adrien Chappuis. *The Drawings of Paul Cézanne: A Catalogue Raisonné.* 2 vols. Greenwich, Conn., 1973.

Cherpin, 1972
Jean Cherpin. *L'Oeuvre gravé de Cézanne.* Marseilles, 1972. Pt. 3. Aix-en-Provence, Pavillon de Vendôme. *Cézanne: L'Oeuvre gravé.* May 30–August 15, 1972.

Chicago, 1952
Chicago, The Art Institute of Chicago. *Cézanne: Paintings, Watercolors & Drawings. A Loan Exhibition.* 1952.

Dorival, 1948
Bernard Dorival. *Cézanne.* New York, 1948.

Druick, 1972
Douglas W. Druick. "Cézanne, Vollard, and Lithography: The Ottawa Maquette for the 'Large Bathers' Colour Lithograph." *Bulletin, The National Gallery of Canada, Ottawa,* vol. 19 (1972), pp. 2–29.

Druick, 1977
Douglas Druick. "Cézanne's Lithographs." In New York, 1977, pp. 119–37.

Faure, 1936
Elie Faure. *Cézanne.* Paris, 1936.

Fry, 1929
Roger Fry. *Cézanne: A Study of His Development.* 3rd ed. New York, 1929.

Gachet, 1952
Paul Gachet. *Cézanne à Auvers: Cézanne graveur.* Paris, [1952].

Guerry, 1950
Liliane Guerry. *Cézanne et l'expression de l'espace.* Paris, 1950.

Ikegami, 1969
Chuji Ikegami. *Cézanne.* Tokyo, 1969.

Jewell, 1944
Edward Alden Jewell. *Paul Cézanne.* New York, 1944.

Loran, 1946
Erle Loran. *Cézanne's Composition: Analysis of His Form with Diagrams and Photographs of His Motifs.* Berkeley, Calif., 1946.

Meier-Graefe, 1920
Julius Meier-Graefe. *Cézanne und sein Kreis: Ein Beitrag zur Entwicklungsgeschichte.* 2nd ed. Munich, 1920.

Meier-Graefe, 1922
Julius Meier-Graefe. *Cézanne und sein Kreis: Ein Beitrag zur Entwicklungsgeschichte.* 3rd ed. Munich, 1922.

Meier-Graefe, 1927
Julius Meier-Graefe. *Cézanne.* Translated by J. Holroyd-Reece. London, 1927.

Miura, 1972
Shumon Miura, Mitsuhiko Kuroe, and Shuji Takashina. *Cézanne.* Edited by Toshio Nishimura. Tokyo, 1972.

Neumeyer, 1958
Alfred Neumeyer. *Cézanne Drawings.* New York, 1958.

New York, 1928
New York, Wildenstein Galleries. *Loan Exhibition of Paintings by Paul Cézanne, 1839–1906.* January 1928.

New York, 1939
New York, Marie Harriman Gallery. *Cézanne, 1839–1939: Centennial Exhibition.* November 7–December 2, 1939.

New York, 1947
New York, Wildenstein. *A Loan Exhibition of Cézanne for the Benefit of the New York Infirmary.* March 27–April 26, 1947.

New York, 1959
New York, Wildenstein. *Loan Exhibition: Cézanne.* November 5–December 5, 1959.

New York, 1963
New York, Columbia University, Department of Art History and Archaeology [held at M. Knoedler and Company]. *Cézanne Watercolors.* April 2–20, 1963.

New York, 1977
New York, The Museum of Modern Art. *Cézanne: The Late Work.* October 7, 1977—

January 3, 1978. Essays by Theodore Reff et al.; catalogue edited by William Rubin.

Novotny, 1937
Fritz Novotny. *Paul Cézanne*. Vienna, 1937.

Novotny, 1938
Fritz Novotny. *Cézanne und das Ende der wissenschaftlichen Perspektive*. Vienna, 1938.

Orienti, 1975
Sandra Orienti. *Tout l'oeuvre peint de Cézanne*. Paris, 1975.

Paris, 1910
Paris, Galerie Bernheim-Jeune. *Exposition Cézanne*. January 10–22, 1910.

Paris, 1920
Paris, Galerie Bernheim-Jeune. *Exposition Cézanne*. December 1–18, 1920.

Paris, 1924
Paris, Galerie Bernheim-Jeune. *Exposition Cézanne*. March 3–22, 1924.

Paris, 1936
Paris, Musée de l'Orangerie. *Cézanne*. 1936.

Paris, 1978
Paris, Grand Palais. *Cézanne: Les Dernières Années (1895–1906)*. April 20–July 23, 1978.

Pfister, 1927
Kurt Pfister. *Cézanne: Gestalt/Werk/Mythos*. Potsdam, 1927.

Philadelphia, 1934
Philadelphia, Pennsylvania Museum of Art. *Cézanne*. November 10–December 10, 1934.

PMA
Philadelphia Museum of Art

Raynal, 1954
Maurice Raynal. *Cézanne*. Geneva, 1954.

Rewald, 1936
John Rewald. *Cézanne et Zola*. Paris, 1936.

Rewald, 1948
John Rewald. *Paul Cézanne: A Biography*. New York, 1948.

Rewald, 1973
John Rewald. *The History of Impressionism*. 4th rev. ed. New York, 1973.

Rewald, 1983
John Rewald. *Paul Cézanne: The Watercolors, A Catalogue Raisonné*. Boston, forthcoming [1983].

Rivière, 1923
Georges Rivière. *Le Maître Paul Cézanne*. Paris, 1923.

Rousseau, 1953
Theodore Rousseau, Jr. *Paul Cézanne (1839–1906)*. New York, 1953.

Schapiro, 1952
Meyer Schapiro. *Paul Cézanne*. New York, 1952.

Venturi, 1936, or Venturi
Lionello Venturi. *Cézanne: Son Art–son oeuvre*. 2 vols. Paris, 1936.

Venturi, 1978
Lionello Venturi. *Cézanne*. Geneva, 1978.

Vollard, 1914
Ambroise Vollard. *Paul Cézanne*. Paris, 1914.

Vollard, 1919
Ambroise Vollard. *Paul Cézanne*. Paris, 1919.

Vollard, 1923
Ambroise Vollard. *Paul Cézanne: His Life and Art*. Translated by Harold L. Van Doren. New York, 1923.

von Wedderkop, 1922
Hans von Wedderkop. *Paul Cézanne*. Leipzig, 1922.

PAINTINGS

1. *HAMLET AND HORATIO* (after Delacroix), c. 1870–74
(*Hamlet et Horatio*)

OIL ON PAPER MOUNTED ON CANVAS
8⅝ x 7⅝″ (21.9 x 19.4 CM.)
COLLECTION OF SYDNEY ROTHBERG, PHILADELPHIA

THROUGHOUT HIS LIFE Cézanne was devoted to Delacroix:[1] some twenty-three paintings relate to the great Romantic artist, drawings directly after Delacroix figures abound,[2] and Cézanne even planned a painting showing the apotheosis of his hero, witnessed by him, Camille Pissarro, Claude Monet, and Victor Chocquet, his most important early supporter and patron.[3] It was certainly Delacroix's rich harmony of color that held Cézanne's lifelong admiration, but the attraction of the intense emotionalism and often charged eroticism of these Romantic works also had a powerful sway over the young Cézanne, particularly in his formative period in the late 1860s and early 1870s. Most of the major paintings of this period—*The Temptation of Saint Anthony* (Venturi 103), *The Orgy* (Venturi 92), *The Rape* (Venturi 101) —have their temperamental origins in works by Delacroix.

Delacroix's illustrations of *Hamlet,* particularly the scene in which Hamlet and Horatio meet at the grave of Yorick, held special appeal for Cézanne. In two drawings

1a. Eugène Delacroix (1798–1863)
"It is the skull of Yorick, the king's fool," 1843
(C'est la caboche d'Yorick, fou du roi)
Lithograph, 11¼ x 8¼"
PMA. Gift of Kitterlinus Lithographic
Manufacturing Co.
46-39-14

1b. Eugène Delacroix
"I am the ghost of your father," 1843
(Je suis l'esprit de ton père)
Lithograph, 10⅛ x 7½"
PMA. Gift of Kitterlinus Lithographic
Manufacturing Co.
46-39-3

NOTES:
1. Cézanne is known to have owned three works by Delacroix, and numerous photographs and prints after his pictures were in Cézanne's studio at his death; *see* Theodore Reff, "Reproductions and Books in Cézanne's Studio," *Gazette des Beaux-Arts,* 102nd year, 6th ser., vol. 56 (1960), pp. 303–9.
2. *See* Sara Lichtenstein, "Cézanne and Delacroix," *Art Bulletin,* vol. 46 (1964), pp. 55–67; and Gertrude Berthold, *Cézanne und die alten Meister* (Stuttgart, 1958).
3. *See* John Rewald, "Chocquet and Cézanne," *Gazette des Beaux-Arts,* 111th year, 6th ser., vol. 74 (July–August 1969), pp. 70–71, figs. 32–33.
4. Loys Delteil, *Le Peintre-Graveur illustré (XIXᵉ et XXᵉ siècles),* vol. 3, *Ingres & Delacroix* (Paris, 1908), no. 75.
5. *See* Gachet, 1952, n.p.

(Chappuis 325–26) he copied the subject directly from Delacroix's lithograph of 1828.[4] Paul Gachet relates that his father, who had an impression of this print at Auvers-sur-Oise, encouraged Cézanne to prepare a plate on this subject, although there is no evidence that the print was ever pulled.[5]

Hamlet and Horatio is a much more ambitious rethinking of Delacroix's treatment of the subject (which he did at least four times, with considerable variation) and, despite its small scale, clearly engaged the young artist in a more complex investigation of Delacroix's genius. This picture is closest to the painted version now in the Louvre, dated 1839, then in a private collection (Robaut 694) but known to Cézanne through the lithograph after it in reverse (fig. 1a), which was in broad circulation. A close comparison of Delacroix's composition with Cézanne's is telling: all the picturesque elements of the grouping of the two gravediggers and the two youths in the earlier work are maintained, but the narrative details, including the skull itself, are only broadly suggested by Cézanne with an agitated and loaded brush. Furthermore, while Delacroix renders the scene within an atmosphere of relative calm, Cézanne summons up a raging storm, which makes the hero's cloak flail above his head against a sinister orange sky shot with violent strokes of deep blue. In these embellishments of the already theatrical composition, Cézanne is most likely recalling another Delacroix illustration to the play, which depicts the early meeting of Hamlet and the ghost of his father on the battlements (fig. 1b). In this fusion of sources, Cézanne succeeds in loading the scene with one more degree of emotional energy and force.

PROVENANCE: Dr. Paul Gachet, Auvers-sur-Oise; Paul Gachet, Auvers-sur-Oise, as of 1934; Private collection, U.S.A.; Knoedler Gallery, New York; William Doyle Galleries, New York, sold September 22, 1982, no. 47

BIBLIOGRAPHY: Venturi, 1936, vol. 1, p. 347; Lionello Venturi, "'Hamlet and Horatio,' A Painting by Paul Cézanne," *Art Quarterly,* vol. 19, no. 3 (Autumn 1956), p. 273, fig. 1 (as c. 35 x 30 cm); Orienti, 1975, p. 88, no. 46

2. LANDSCAPE, AUVERS, c. 1873
(Quartier Four, à Auvers)

OIL ON CANVAS

18¼ x 21¾" (46.3 x 55.2 CM.)

PHILADELPHIA MUSEUM OF ART

THE SAMUEL S. WHITE, 3RD, AND VERA WHITE COLLECTION

67-30-16

IN 1873, a year after the birth of his son Paul, Cézanne settled in Auvers-sur-Oise, a rural hamlet north of Paris. The young doctor Gachet, the first real enthusiast and collector of the group of painters who in 1874 would be tagged "Impressionists," offered the family space in his large house on the outskirts of the village just at the time when the presence of a mistress, and a son, prevented Cézanne's retreat to his parents' house in Aix (*see* no. 23R).

Beyond these domestic conveniences, perhaps a more compelling reason for Cézanne's move was the proximity of Pissarro, who was living in the nearby village of Pontoise, and who was often in the company of Armand Guillaumin and Monet. The stay at Auvers during 1873 and 1874 witnessed a major change in the artist's style: while he would not yet completely abandon the emotional subjects of his earlier period (Doctor Gachet himself owned the *Modern Olympia*, which he would lend to the first group showing of the Impressionists in 1874; *see* no. 24), a greater range of themes began to emerge, among them a series of still lifes (sometimes from flowers arranged by Madame Gachet), and landscapes. According to Gachet, Cézanne worked out of doors almost constantly and the calm, lush valley of the Oise with the village compactly settled on its banks seemed to lend itself perfectly to his interests.

It was Pissarro who gave Cézanne the foundations for a new means of analyzing nature and reporting his observations calmly and with deliberation[1]—the revolutionary principles of Impressionism, which were just being formulated at this time. His struggle to grasp many of the new attitudes and to bring them within his own expressive terms is perhaps nowhere more clearly evident than in this modest view over a wall looking down at a tightly clustered group of houses in Auvers. The palette knife which had served him so well in his violent subjects has been abandoned for blunt, carefully detached strokes of the brush; color has been introduced in considerable variety and, particularly through the screen of leaves across the top, a certain "impressionistic" atmospheric effect can be found. Yet it is a picture in which Cézanne essentially labored to establish, through a complex set of planes, a bold and unified space within a very closed and focused viewpoint. A comparison with *The Climbing Path*, a painting by Pissarro (fig. 2a) of one or two years later (and a painting in which the older artist seems to draw nearest to Cézanne), is particularly telling: in the Pissarro there is the same downward viewpoint, a similar use of curving forms leading into space, and a screen of trees through which light passes, but the effect is of a gentle expanse of space and air, whereas the Cézanne is more firmly structured and has little of its sense of the transient moment.

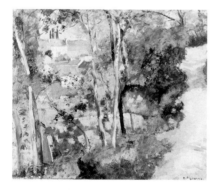

2a. Camille Pissarro (1830–1903)
The Climbing Path, 1875
(*L'Hermitage, Pontoise*)
Oil on canvas, 21⅜ x 25⅞"
The Brooklyn Museum.
Gift of Dikran G. Kelekian

NOTE:

1. In 1873 Cézanne copied a landscape of Louveciennes by Pissarro (Venturi 153).

PROVENANCE: Duret, by 1924; Bernheim-Jeune, Paris; Samuel S. White, 3rd, Ardmore, Pa., by 1928; Philadelphia Museum of Art, by bequest, 1967

EXHIBITIONS: Philadelphia, Pennsylvania Museum of Art, "The White Collection" (December 9, 1933–January 10, 1934); Philadelphia, 1934, no. 45; New York, 1947, p. 38, no. 6; Philadelphia, PMA, *Masterpieces of Philadelphia Private Collections: Part II* (May 20–September 15, 1950), p. 95, no. 11; Philadelphia, PMA, "S.S. White, 3rd Collection" (1950); Philadelphia, PMA, "The Samuel S. White, 3rd, and Vera White Collection" (1962–66)

BIBLIOGRAPHY: *Bulletin de la Vie Artistique,* March 1, 1925, repro. p. 109; Venturi, 1936, vol. 1, p. 101, no. 157, vol. 2, pl. 41, no. 157; *The Samuel S. White, 3rd, and Vera White Collection, Philadelphia Museum of Art Bulletin,* vol. 63, nos. 296–97 (January–March 1968 and April–June 1968), p. 87, no. 13; Orienti, 1975, p. 93, no. 148

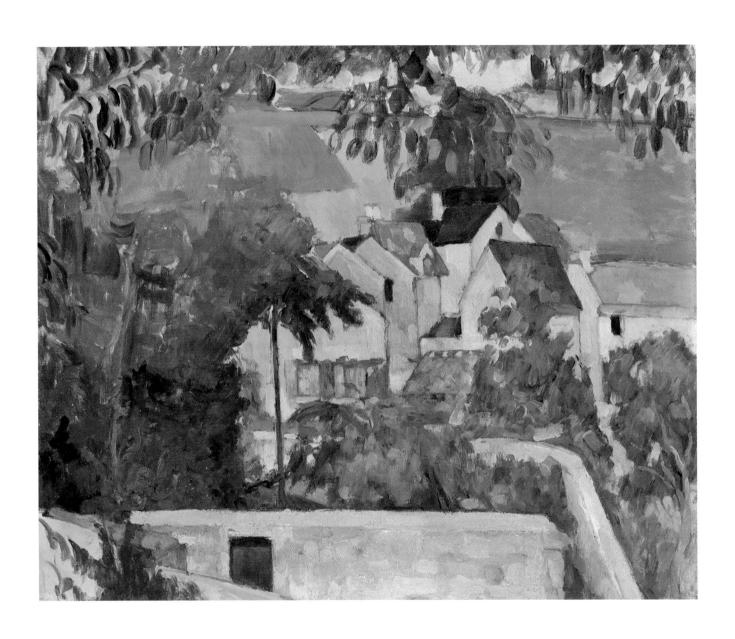

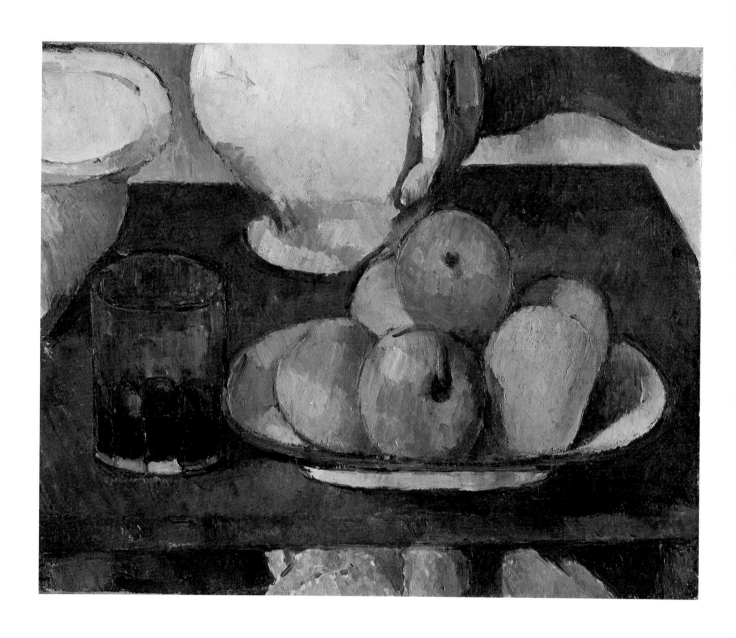

3. *STILL LIFE WITH APPLES,* 1877–79
(Nature Morte avec Fruits et Verre de Vin)

OIL ON CANVAS

10⅜ x 12⅞″ (26.3 x 32.7 CM.)

PHILADELPHIA MUSEUM OF ART

THE LOUISE AND WALTER ARENSBERG COLLECTION

50-134-AI-32

CLOSE EXAMINATION tentatively confirms John Rewald's suggestion that certain Cézanne paintings on this modest scale may well be cut from larger compositions, essentially salvaged by the artist (perhaps even quite some time after their execution) as he destroyed the remainder. At the bottom of the canvas the brushstrokes terminate completely near the edge, leaving a thin area of ground visible in some places, whereas the paint extends fully to the edge on the other three sides, giving the appearance of having been cut off after the paint dried. This would help somewhat to explain the particularly abrupt composition of this densely painted little picture and explain its sense of being "advanced," particularly with regard to the cut-off pitcher and the truncated basin, which suggest elements more akin to the later still lifes of Gauguin. *Still Life with Apples* is close to another still life containing the same basin and glass (Venturi 495); however, there the space is more open at either side.

Compared to *The Dessert* (no. 4), it is a remarkably humble and modest gathering of objects: a simple white pitcher; a heavy ceramic basin; the plate with the heavily glazed blue edge that Cézanne loved so much piled with apples; a pear; and a solid fluted tumbler with a little wine in it. As can be readily seen in the accidental gouge in the uppermost apple (probably a mistake that occurred when the paint was still wet), the build-up of layers is remarkably thick across the surface, with the most deliberate and considered, lean brushstrokes—applied apparently straight from the tube without thinning, regardless of the texture of the objects depicted. These loaded strokes take on an almost molten quality as they define the forms, the whole effect being one of great richness and solidity with an opaque luminosity of color.

PROVENANCE: Ambroise Vollard, Paris?; Galerie Barbazanges, Paris; Louise and Walter Arensberg, New York and Hollywood, Calif., as of 1920; Philadelphia Museum of Art, 1950

EXHIBITIONS: Philadelphia, The Pennsylvania Academy of the Fine Arts, *Catalogue of an Exhibition of Paintings and Drawings by Representative Modern Artists* (April 17–May 9, 1920), p. 9, no. 58 or 59; New York, The Metropolitan Museum of Art, *Loan Exhibition of Impressionist and Post-Impressionist Paintings* (May 3–September 15, 1921), no. 11; San Francisco, The California Palace of the Legion of Honor, *Exhibition of French Painting from the Fifteenth Century to the Present Day* (June 8–July 8, 1934), no. 73; New York, Marie Harriman Gallery, *Chardin and the Modern Still Life* (1936), no. 11; Chicago, The Art Institute of Chicago, *20th Century Art. From the Louise and Walter Arensberg Collection* (October 20–December 18, 1949), p. 48, no. 36; Allentown, Pa., The Allentown Art Museum, *Four Centuries of Still Life* (December 12, 1959–January 31, 1960), no. 21, fig. 45; Gifu, Japan, Musée des Beaux-Arts, *Paris autour de 1882: Le Développement de la peinture moderne en France et Hôsui Yamamoto* (November 3–December 19, 1982), no. 71

BIBLIOGRAPHY: Philadelphia, PMA, *The Louise and Walter Arensberg Collection—20th Century Section* (Philadelphia, 1954), no. 31; Philadelphia, PMA, *Check List of Paintings in the Philadelphia Museum of Art* (Philadelphia, 1965), p. 12

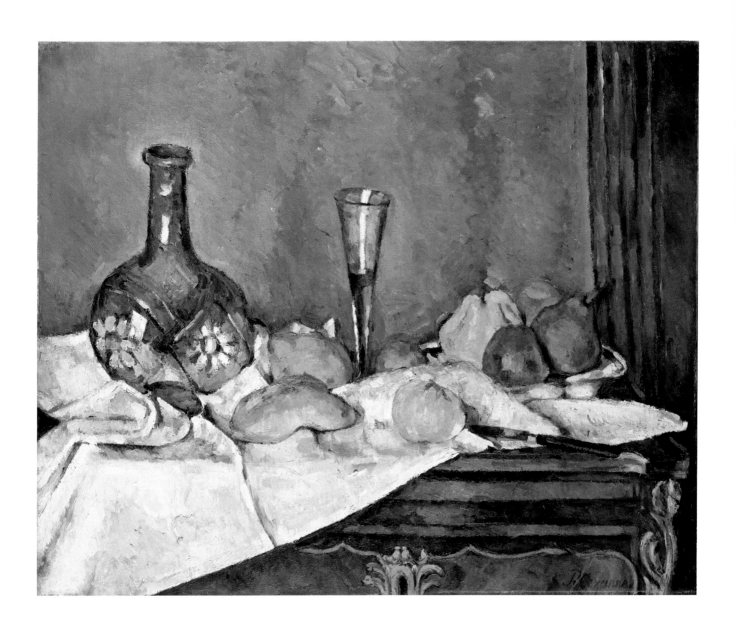

4. *THE DESSERT,* 1877 or 1879
(Un Dessert)

OIL ON CANVAS
23¼ x 28¾″ (59 x 73 CM.)
PHILADELPHIA MUSEUM OF ART
MR. AND MRS. CARROLL S. TYSON, JR. COLLECTION
63-116-5

CÉZANNE HAD THE GOOD FORTUNE of having two early supporters who befriended him
and bought his pictures—Doctor Gachet and, more important, Victor Chocquet, who,
at the time of his death in 1891, owned thirty-five paintings by Cézanne as well as many
watercolors. A civil servant in the Parisian customs bureau, Chocquet bought his first
Cézanne (a small nude) in 1875, when Renoir took him to the shop of the humble

pigment seller, Père Tanguy. Cézanne, in turn, introduced Chocquet to Monet the following year, and he became one of the most articulate and loyal supporters of the Impressionists.

The initial bond between Cézanne and Chocquet was melded, no doubt, through their mutual admiration for Delacroix (Chocquet owned twenty-three Delacroix paintings), and their correspondence, which continued until the patron's death, is full of references to this artist. Chocquet also was interested in fine old furniture, porcelain, and glass, which furnished his apartment overlooking the Tuilleries at 198, rue de Rivoli. It was there, in all likelihood, that Cézanne painted this still life, either in 1877 or 1879 (he stayed in the South during the entire year of 1878). The rococo Louis XV commode, with its various inlaid woods and ormolu mounts, as well as the elegantly fluted glass and cut-glass carafe, far outshines the more humble domestic objects found in other Cézanne still lifes. Yet, Cézanne seems not to have been distracted in any way from his primary spatial intentions by these elegant, high-style objects. The thick granular paint surface and the deeply incised and reworked contours, as well as the ocher background, which absorbs light with the same voracity as the objects, place this still life in a series of paintings which are remarkable for their sparse monumentality.

The picture was sold in 1899 from the estate settlement of Madame Chocquet to the dealer Durand-Ruel (who bought over half the Cézannes at the sale) for 3,500 francs. This suggests that Cézanne, toward the end of his life, was beginning to find some audiences for his work, albeit some twenty years after Chocquet's recognition of his genius in the 1870s.

PROVENANCE: Victor Chocquet, Paris; Galerie Georges Petit, Paris, sale, Chocquet Collection, July 1–4, 1899, no. 17; Durand-Ruel, Paris, New York; Mr. and Mrs. Carroll S. Tyson, Jr., Philadelphia, by 1928; Philadelphia Museum of Art, by bequest, 1963

EXHIBITIONS: Paris, Third Impressionist Exhibition, 1877[?]; probably Paris, *Salon des Indépendants* (1901), no. 154, or (1902), no. 321; London, Grafton Galleries, *Pictures by Boudin, Cézanne, Degas…Exhibited by Messrs. Durand-Ruel & Sons…*(January–February 1905), no. 39; Zurich, Kunsthaus, *Französische Kunst des XIX. und XX. Jahrhunderts* (November 1917), no. 22; Paris, 1924; Vienna, *LXXXII. Ausstellung der Sezession: Führende Meister der französische Kunst im 19. Jahrhundert* (March–April 1925), no. 85; Paris, *L'Art français au service de la science française* (1925), no. 163; New York, 1928, no. 3; Philadelphia, Pennsylvania Museum of Art, "Inaugural Exhibition" (1928); Philadelphia, 1934, no. 23; New York, 1947, p. 24, no. 10; Philadelphia, PMA, *Masterpieces of Philadelphia Private Collections* (May 1947), p. 72, no. 11

BIBLIOGRAPHY: *The Studio* (April 1903), repro. p. 168; Camille Mauclair, *The French Impressionists (1860–1900)* (London, 1903), repro. p. 149; V. Pica, *Gli impressionisti francesi* (Bergamo, 1908), repro. p. 197; *Bulletin de la Vie Artistique* (April 1920), repro. p. 269; Léon Leclère [Tristan-L. Klingsor], *Cézanne* (Paris, 1923), pl. 6; Rivière, 1923, repro. opp. p. 182; *L'Amour de l'Art* (1924), repro. p. 40; Léon Leclère [Tristan-L. Klingsor], *Cézanne*, trans. J.-B. Manson (New York, 1924), pl. 6; Venturi, 1936, vol. 1, p. 109, no. 197, vol. 2, pl. 53, no. 197; Rewald, 1948, fig. 71; John Rewald, "The Collection of Carroll S. Tyson, Jr., Philadelphia, U.S.A.," *The Connoisseur*, vol. 134 (August 1954), repro. p. 65 (reprinted in *Philadelphia Museum of Art Bulletin*, vol. 59, no. 280 [Winter 1964], repro. p. 73); Maurice Raynal, *Cézanne* (Geneva, 1954), repro. p. 42; *La Chronique des Arts*, p. 71, no. 233 (supplement to *Gazette des Beaux-Arts*, 106th year, 6th ser., vol. 63, no. 1141 [February 1964]); Horace H.F. Jayne, "Tyson Collection: A Painter's Eye on Masterworks," *Art News*, vol. 63, no. 5 (September 1964), repro. p. 30; Philadelphia, PMA, *Check List of Paintings in the Philadelphia Museum of Art* (Philadelphia, 1965), p. 12; John Rewald, "Chocquet and Cézanne," *Gazette des Beaux-Arts*, 111th year, 6th ser., vol. 74 (July–August 1969), p. 57, fig. 17; Orienti, 1975, p. 95, no. 196; Venturi, 1978, pl. 1

5. SAINT-HENRI AND THE BAY OF L'ESTAQUE, 1877–79
(Saint-Henri, et la Baie de l'Estaque)

OIL ON CANVAS

26¼ x 32⅝″ (66.7 x 82.9 CM.)

PRIVATE COLLECTION (LENT BY A MEMBER OF THE TYSON FAMILY)

THE VILLAGE OF Saint-Henri lies between Marseilles and L'Estaque on the bay. Its prominent church tower, Notre Dame de la Garde, appears in several of Cézanne's views of the bay (*see* no. 11). Cézanne worked along the bay (which he had known from his childhood) in 1876, when he settled his wife and child in nearby Marseilles, and continued to paint there over the next three years.

While this landscape is sometimes placed chronologically closer to the other two views of the region shown here (nos. 9, 11), which are dated to the 1880s, Rewald argues for a somewhat earlier date of the late 1870s. Throughout the 1870s Cézanne's landscapes had a progressively more controlled evenness of handling, the origins of which are witnessed here by the *Landscape, Auvers* (no. 2), and any interest in local textures and atmospheric effects became secondary to the overall pictorial unity. Here, in a closed view that contains the bay completely within the promontory of land beyond, the water is handled with the same regular blunt brushstrokes as the houses, land, and sky, at the same time being convincing and grand in the modulation of blues and greens across the surface. Perhaps to relieve this studied regularity, some contours, particularly the S-curve of the retaining wall in the foreground and the slope of the bank into the sea just beyond, take on a gentle lyricism, echoed by the billowing clouds of blue smoke emitted from the stacks of the factories lining the shoreline. There is a constructed, set air about this picture—more painting than nature—which has led Guerry to observe: "The step toward abstract unification is striking. There is no longer a first plane and background, real space has been completely encompassed by a constructed space, abstracted systematically. The painting has truly become that 'playing card' which Cézanne mentions in his letter to Pissarro."[1]

The reference is to the famous letter of 1876, written from L'Estaque, in which Cézanne describes the bay and its surroundings: "It is like a playing-card,—red roofs over the blue sea....The sun is so terrific here that it seems to me as if the objects were silhouetted not only in black and white, but in blue, red, brown and violet. I may be mistaken, but this seems to me to be the opposite of modelling."[2]

NOTES:

1. Guerry, 1950, p. 84 (author's translation).
2. Cézanne, 1941, pp. 102–3.

PROVENANCE: Ambroise Vollard, Paris; Josse Hessel, Paris; Paul Rosenberg, Paris; Mr. and Mrs. Carroll S. Tyson, Jr., Philadelphia; Private collection, Philadelphia

EXHIBITIONS: Paris, Galerie Vollard, *Exposition Paul Cézanne* (1895); Zurich, Kunsthaus, *Französische Kunst des XIX. und XX. Jahrhunderts* (November 1917), no. 26; Paris, 1920, no. 30; New York, 1928, no. 13; Philadelphia, 1934, no. 14A; New York, 1947, p. 38, no. 20; Philadelphia, PMA, *Masterpieces of Philadelphia Private Collections* (May 1947), p. 73, no. 19

BIBLIOGRAPHY: *Kunst und Künstler* (1907), repro. p. 97; Vollard, 1914, pl. 34; von Wedderkop, 1922, repro.; Ikouma Arishima, "Cézanne," *Ars,* vol. 14 (1926), pl. 36; Pfister, 1927, fig. 70; Venturi, 1936, vol. 1, p. 151, no. 398, vol. 2, pl. 110, no. 398; Guerry, 1950, pp. 84, 91; Orienti, 1975, p. 105, no. 414

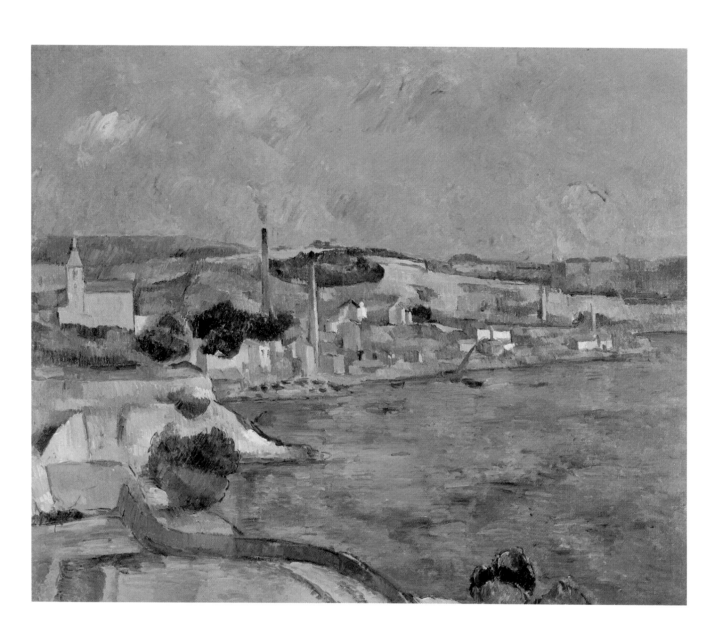

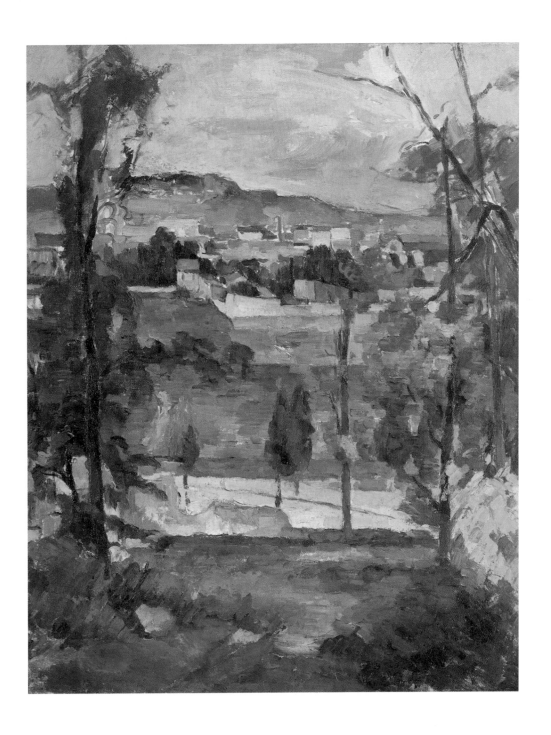

6. *LANDSCAPE: ILE DE FRANCE*, c. 1879
(Village derrière des Arbres, Ile de France)

OIL ON CANVAS
25⅝ x 18⅛″ (65.1 x 46 CM.)
PRIVATE COLLECTION

IN THE CONTEXT of this presentation, *Landscape: Ile de France* makes a striking comparison to Cézanne's view of the village of Auvers painted some six years earlier (no. 2). There, albeit for a relatively brief time, he labored under the new principles of Impressionism, using a variety of brushstrokes for different textures and lighting effects,

6a. Armand Guillaumin (1841–1927)
Landscape, c. 1879
Oil on canvas, 24¼ x 19¾"
Private collection, New York

NOTES:
1. Fritz Novotny, *Painting and Sculpture in Europe, 1780 to 1880,* 2nd ed. (Baltimore, 1970), p. 207.
2. John Rewald, "Cézanne and Guillaumin," p. 349, in Albert Châtelet and Nicole Reynaud, eds., *Études d'art français offertes à Charles Sterling* (Paris, 1975).
3. *Ibid.*

screening elements through foliage to create planes of space. This was never a completely resolved nor satisfying manner for the artist, and its very goal, a radiant depiction of the transient moment, was fundamentally contrary to both his temperament and his vision. Afterward, during the remaining years of the 1870s, he looked elsewhere to find his own landscape style, and in works such as this view near Pontoise, he achieved his first full, mature style independent of Impressionist attitudes, as Fritz Novotny has so eloquently stated:

> Dependence on Impressionism is still discernible in every stroke of the brush, and it is thus easy to understand why Cézanne is so often included among the Impressionists. Yet everything is mysteriously changed. Here is indeed a fundamental reversal of Impressionism. Of Cézanne's painting—and indeed of that of Seurat, though in a different sense—it can be said that the sun of Impressionism has set, but that everything is irradiated with a new clarity, with an unprecedented light. In comparison, the serene spiritualization of Impressionism seems heavy. The magic of the momentary and the actual is transformed into the mystery of the lasting and the eternal, and vibrating, busy life has become a resonant silence. In small, apparently haphazard fragments from nature—but not in the ostentatiously small, as in the works of the Romantics—the boundless, the immeasurable, has been expressed, without Romantic horizons and without the broad expanses of the sky.[1]

Rewald has discovered that Cézanne almost undoubtedly painted this landscape in the company of his friend Guillaumin.[2] The two artists, who are known to have worked together in front of the same motif (*see* fig. 6a), probably set themselves a slight distance apart on the hillside looking over the same village in the Ile de France. With great vitality Guillaumin records the curves of the trees, the gently receding meadow before the hamlet, and the soft profile of the hill beyond, while Cézanne, with considerably more force at the loss of a transient lyricism, straightens the trees and blocks in the planes of the meadow, adapting the houses and the hill itself into a series of planes and stepped levels that give his work a volume and structure quite unlike that of his companion. Rewald also suggests that, given the bareness of Cézanne's trees as compared to Guillaumin's, Cézanne may well have remained working at the site longer, into the autumn (the bush on the right has turned bright yellow), allowing him time to construct his more serious and grave statement.[3]

PROVENANCE: Oskar Bondy, Vienna, acquired Paris, 1905–7; Dr. Hermann Eissler, Vienna, by 1913; Private collection, Paris; Rodman W. Edmiston, Rose Valley, Pa.; William H. Taylor, Philadelphia, acquired 1936; Private collection, Philadelphia

EXHIBITIONS: Budapest, Ernst-muzeum (1913), no. 73; Vienna, *LXXXII. Ausstellung der Sezession: Führende Meister der französische Kunst im 19. Jahrhundert* (March–April 1925), no. 82

BIBLIOGRAPHY: *L'Amour de l'Art* (May 1925), repro. p. 177; Pfister, 1927, fig. 53; Venturi, 1936, vol. 1, p. 103, no. 165, vol. 2, pl. 44, no. 165; Fritz Novotny, *Painting and Sculpture in Europe, 1780 to 1880,* 2nd ed. (Baltimore, 1970), pl. 173; Orienti, 1975, p. 93, no. 161; John Rewald, "Cézanne and Guillaumin," fig. 224, in Albert Châtelet and Nicole Reynaud, eds., *Études d'art français offertes à Charles Sterling* (Paris, 1975)

7. *LANDSCAPE AT PONTOISE, 1879–82*
(La Côte du Galet, à Pontoise)

OIL ON CANVAS
23⅝ x 28¾″ (60 x 73 CM.)
PRIVATE COLLECTION (LENT BY A MEMBER OF THE TYSON FAMILY)

AFTER THE NOTABLE lack of success of the Impressionist exhibition in 1877, Cézanne resolved to detach himself completely from the group and began a decade of work that some modern critics have called his "constructivist period."[1] It was a time when his landscapes often present views of marked asymmetry and vast compositional and spatial complexity. This was a period that produced some of his greatest and most innovative achievements, but few works achieve the calm and resolution of this beautiful view of the little valley behind Pontoise. The space is grandly realized with a patient ease and deliberation quite different from the panoramic views of the bay at L'Estaque (nos. 5, 9) or the heroic presentations of Mont Sainte-Victoire (nos. 20, 21). Each passage defining the verdant hillside in mid-summer and following the road as it descends through the poplars into the village and then progresses up the hill is limpidly clear in space. It is perhaps most telling that, despite a fundamental difference in handling, its expressive tenor is most closely related to similar views by Pissarro painted almost a decade earlier.

PROVENANCE: Egisto Fabbri, Florence, by 1910; Paul Rosenberg, Paris; Wildenstein, New York; Mr. and Mrs. Carroll S. Tyson, Jr., Philadelphia; Private collection, Philadelphia

EXHIBITIONS: Paris, 1910, no. 22; Venice, *XIIᴬ Esposizione internazionale d'arte della città di Venezia. Catalogo*, 2nd ed. (1920), p. 123, no. 13; Cambridge, Mass., Harvard University, Fogg Art Museum, *Exhibition of French Painting of the Nineteenth and Twentieth Centuries* (March 6–April 6, 1929), p. 9, no. 5a; Philadelphia, 1934, no. 25; Paris, 1936, no. 51, pl. 25; New York, 1947, p. 33, no. 15

BIBLIOGRAPHY: *Dedalo*, vol. 1 (1920), repro. p. 63; Meier-Graefe, 1922, repro. p. 212; *L'Amour de l'Art* (November 1924), repro. p. 343; Pfister, 1927, fig. 99; *L'Arte* (July 1935), pl. 10; Venturi, 1936, vol. 1, p. 134, no. 319, vol. 2, pl. 86, no. 319; Novotny, 1938, pp. 128–29, fig. 50; G. Schildt, *Cézanne* (Stockholm, 1946), fig. 26; Dorival, 1948, pl. 54; Rewald, 1948, repro. opp. p. 126; Kurt Badt, *Die Kunst Cézannes* (Munich, 1956), p. 241, fig. 43; Orienti, 1975, p. 105, no. 406

NOTE:
1. Orienti, 1975, p. 100.

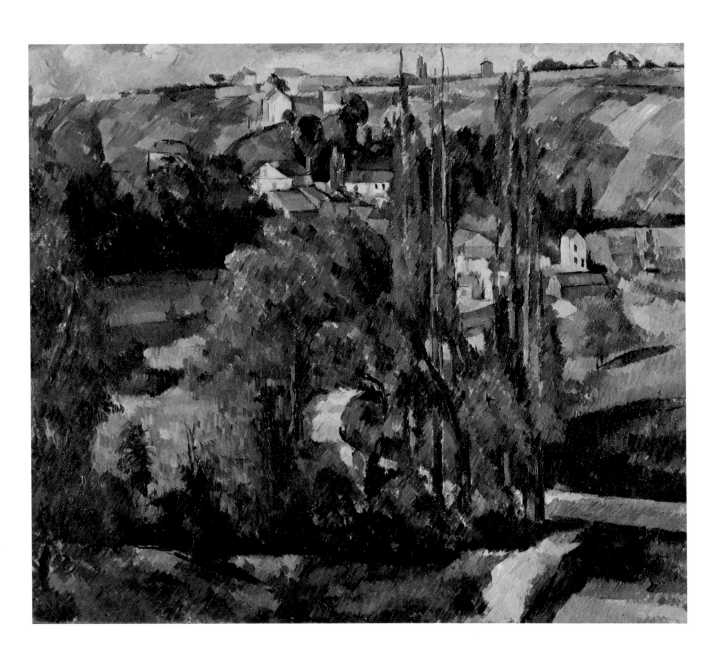

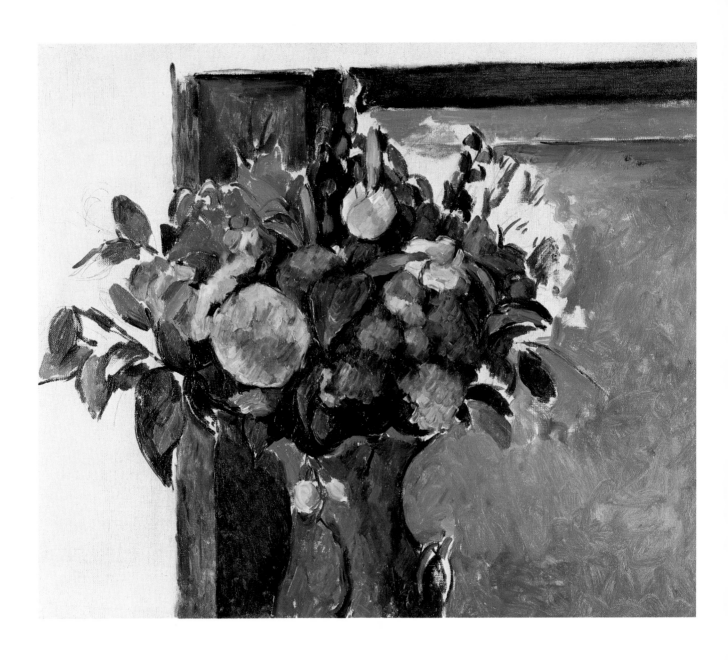

8. *FLOWERS IN A ROCOCO VASE,* 1879–82
(Fleurs dans un Vase)

OIL ON CANVAS
18⅛ x 21⅝″ (46 x 55 CM.)
PRIVATE COLLECTION

SPILLING FROM A VASE in all directions, even on the left, out of the picture, is an abundant array of flowers. The viewpoint is from an angle, close up, and the foot of the vase is cut off. The background, composed of three parallel planes, shows a wall, a door jamb continuing at the top as part of a molding, and an open door indicated only by the bare ground of the canvas. The numerous freely drawn pencil lines still evident, as well as the broadly worked handling of the flowers, vase, and background, suggest that Cézanne only blocked this work in, perhaps abandoning it when his colorful subject wilted and died. This "unfinished" state is not uncommon in Cézanne's flower pictures, perhaps for this very reason (*see* Venturi 361, 511, 748, 755).

This work may be compared to a more finished picture of similar dimensions belonging to Norton Simon, which shows the same vase and flowers, cropped in a nearly identical manner (fig. 8a). Other than the degree of finish, there are only two major differences: the vase sits on a continuous green shelf and the wall is decorated with a pattern of diagonal lines and quatrefoils. Venturi dates these two pictures on the basis of the wallpaper, which he feels must have decorated Cézanne's studio either in Melun, or in Paris at 32, rue de l'Ouest, where he lived from 1879 to 1882.

The presence of two such similar pictures, whatever their dates, poses certain problems. Is this painting a preparatory "sketch" for the other one, perhaps abandoned because of a dissatisfaction with the spatial complexity of the background? Or, rather, is this a loose rethinking of the other composition for the purpose of experimenting with different spatial relationships in the background? Such close similarities are rare in Cézanne's known works, but he is an artist for whom an assumption of consistent working methods is extremely dangerous. Perhaps we should simply (and happily) accept the fact that this lovely subject—a gathering of beautiful pinks, purples, and oranges against a neutral and somber background—did engage his interest in a close and sustained manner.

The great appeal of this subject is documented through the interest it held for another master of flower painting, Odilon Redon, who did a freely worked copy of the Norton Simon picture in 1896.[1]

8a. Paul Cézanne
Vase of Flowers
Oil on canvas, 18½ x 21¾″
The Norton Simon Foundation,
Pasadena, Calif.

PROVENANCE: Mme van Blaaderen Hoogendijk, The Hague; M.C. Hoogendijk, The Hague (d. 1912); Galerie E. Bignou, Paris; Reid & Lefevre Gallery, London; Mrs. Clark, Washington, D.C.; Private collection, Philadelphia

EXHIBITIONS: New York, M. Knoedler & Company, Incorporated, *A Century of French Painting: Exhibition Organised for the Benefit of the French Hospital of New York* (November 12–December 8, 1928), no. 25; New York, Wildenstein & Co., Inc., *A Loan Exhibition of Six Masters of Impressionism* (April 8–May 8, 1948), pl. 3

BIBLIOGRAPHY: Venturi, 1936, vol. 1, p. 143, no. 360, vol. 2, pl. 99, no. 360; Orienti, 1975, pl. 109, no. 488

NOTE:
1. Pasadena, Calif., The Norton Simon Museum, *Selected Paintings at the Norton Simon Museum, Pasadena, California* (London, 1980), repro. p. 10.

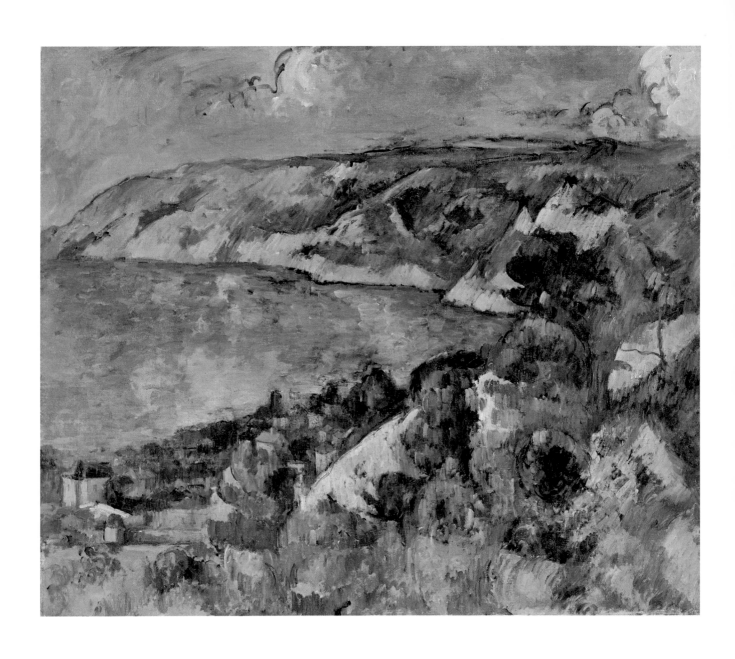

9. BAY OF L'ESTAQUE, 1879–83
(La Baie de l'Estaque)

OIL ON CANVAS
23½ x 28¾" (59.7 x 73 CM.)
PHILADELPHIA MUSEUM OF ART
MR. AND MRS. CARROLL S. TYSON, JR. COLLECTION
63-116-21

THIS PAINTING has long been an enigma for Cézanne scholars. Venturi noted in 1936: "The clouds, as well as the accents on the promontory and the foreground, would seem to have been added later: all the other areas are handled in a regular and light manner, while the brushwork in these areas is leaden and without character. It is possible that the signature is also a later addition."[1] More disconcerting, however, than the disparate handling of paint is the ghostly image of an oval face in the water, which has always been perceptible to the naked eye. This has recently been rendered more clearly visible through infra-red reflectography (fig. 9c), which clearly demonstrates that Cézanne executed this view of the bay of L'Estaque directly over a vertical portrait turned on its side. It was because of this distorting pentimento that the Museum of Fine Arts in Boston sold the picture in 1942.[2] Recent cleaning and conservation, however, have quite fully justified Carroll Tyson's foresight in purchasing it shortly thereafter.

The image that lies beneath the landscape is a portrait of Madame Cézanne, shown full face, seated, and to her waist, but not including her hands. She is wearing a blouse with a scalloped collar under a dark blue dress, which appears to button up the front. The portrait seems to be closest to the one in Houston (fig. 9b), although it is much less finished in the background, which seems to have ranged from a pale yellow-ocher to a green-blue (much of this remains visible through the landscape, particularly at the left side of both top and bottom). Remarkably, there is no evidence that the artist attempted either to rub out this image or, using the more standard procedure, to paint over it lightly with a neutral tone before taking up the second composition. Indeed, several features of the landscape were dictated by the forms beneath; most clearly, the expanse of the widening bay, which fits exactly the scale of her head and hair, and the contour of the mountain, which follows the outline of her left shoulder and arm. This discovery is, in itself, somewhat surprising given the fact that Cézanne frequently proclaimed his loyalty to the observed motif, and is all the more disconcerting when one compares a photograph taken at the site above the village, looking to the north and west (fig. 9a). Perhaps in a very unselfconscious and subjective way, this was clearly an alignment of preexisting forms on a canvas with observed topography, which is, as is so often the case with Cézanne, both bewildering and wonderful.

Even before the laboratory examination, Cézanne's act of overpainting part of the surface was documented in 1927 in a brief article in the journal *Rumeur* entitled "Faux et repeints." The author Maximilien Gauthier related that he had interviewed an unknown painter (whom Rewald was able to establish as Gauguin's friend Emile Schaufennecker[3]) who had once retouched several of Cézanne's paintings, including this one: "In the blue of the water appeared an eye—a nose—*repoussaient*—as one says in the language of painting. A few touches well applied, and it completely disappeared."[4] It, of course, did not disappear completely, as one can see today.

Schaufennecker's attempts to conceal this apparition have now been removed, replaced with minimal strokes to obscure to a small degree the disturbing aspects of the underimage. But it is apparent that Cézanne himself did confront this problem, if not by painting out some of the primary features (both the eyes and the nose clearly show

9a. *View of L'Estaque*
Photograph by John Rewald

through his own application of blue for the water) then by applying to the left of the head, a series of pink strokes (running to bright vermilion at some of the edges), which pick up the flesh tone of the face as they lead the eye beyond it into the open sea. An ingenious but, some might think, overly complicated solution to an optical problem.

Venturi's concern about overpainting are, therefore, justified, although not in the areas that he found suspect. The same cleaning that revealed Schaufennecker's work also confirmed that all the other strokes, including those of the billowing clouds and the pink highlights, are very much those of Cézanne.

It would therefore appear that (putting the problems of the underpainting aside) this is hardly a classic example of Cézanne in his "constructivist mode" as it has sometimes been called. Rather it is a quite complex unity of various handlings. The brushwork both to the left of land in the foreground and the cliff beyond is very measured and regular, establishing a strong sense of distance across the bay. Yet, there is a departure from this regularity in other areas of the canvas: within the foreground and into the trees to the right and the higher ground there is a compellingly exuberant multi-direction of strokes and an explosive movement of one form out of another. This effect is carried into the sky and clouds, which are painted with a series of curling and swiftly calligraphic, almost rococo, lines in blue. Furthermore, enough pinks and vermilions are present—particularly in the water, but throughout the landscape as well—to give the painting an overall rose tone, making it a picture of great charm and loveliness, despite (or, perhaps, because of) the massive solidity of the high cliffs and the encaptured bay.

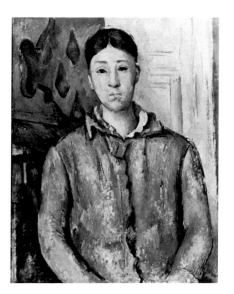

9b. Paul Cézanne
Madame Cézanne in Blue
Oil on canvas, 29 x 24"
The Museum of Fine Arts, Houston
Robert Lee Blaffer Memorial Collection

9c. Infrared reflectography video image of
Bay of L'Estaque (overall view)
PMA. Conservation Department,
taken January 13, 1983

Finally, recent examination of the signature, which was sliced off the bottom when the canvas was relined in the past, does confirm it as completely original, which indicates—despite modern difficulties with the picture—that Cézanne was sufficiently satisfied to declare it finished. That this is the case—and that it is one of the most successfully exuber... landscapes of this period—is now happily revealed again through cleaning and the removal of Schaufennecker's rather heavy-handed "restoration."

NOTES:

1. Venturi, 1936, vol. 1, p. 179, no. 489 (author's translation).
2. *See* Charles C. Cunningham to Henry Gardiner, June 5, 1964 (PMA Archives).
3. Gauthier to Rewald, September 29, 1972.
4. Maximilien Gauthier, "Faux et repeints," *Rumeur,* November 26 and December 1, 1927.

PROVENANCE: Gustave Fayet, Paris; Galerie E. Druet, Paris, by 1910; Charles Pacquement, Paris; Galerie Georges Petit, Paris, sale, Pacquement Collection, December 12, 1932, no. 13; G. Bernheim, Paris; S.A. Denio; Museum of Fine Arts, Boston, to 1942; Julius Weitzner, New York; Schoeneman Gallery, New York; Mr. and Mrs. Carroll S. Tyson, Jr., Philadelphia; Philadelphia Museum of Art, by bequest, 1963

EXHIBITIONS: London, Grafton Galleries, *Manet and the Post-Impressionists* (1911), no. 8; Paris, *Chambre Syndicale de l'Antiquité et des Beaux-Arts, Première Exposition...au profit de la Société des Amis du Luxembourg* (March 10–April 10, 1924), no. 183; Paris, *Trente Ans d'art indépendant* (1926), no. 2872; Paris, *Mers et plages de Delacroix à nos jours* (1929), no. 11; Philadelphia, PMA, *Masterpieces of Philadelphia Private Collections* (May 1947), p. 73, no. 26; New York, 1947, p. 54, no. 40

BIBLIOGRAPHY: C. Lewis Hind, *The Post Impressionists* (London, 1911), repro. opp. p. 38; *L'Amour de l'Art* (1924), p. 52, no. 2; Maximilien Gauthier, "Faux et repeints," *Rumeur,* November 26 and December 1, 1927; *Bulletin de l'Art* (January 1933), repro. p. 51; Venturi, 1936, vol. 1, p. 170, no. 489, vol. 2, pl. 148, no. 489; Novotny, 1938, p. 206, no. 110; Loran, 1946, p. 106, pl. 27; Jean Louis Vaudoyer, *Les Peintres provençaux de Nicolas Froment à Paul Cézanne* (Paris, 1947), repro. p. 86; Gotthard Jedlicka, *Cézanne* (Bern, 1948), no. 33; John Rewald, "The Collection of Carroll S. Tyson, Jr., Philadelphia, U.S.A.," *Philadelphia Museum of Art Bulletin,* vol. 59, no. 280 (Winter 1964), repro. p. 77; Philadelphia, PMA, *Check List of Paintings in the Philadelphia Museum of Art* (Philadelphia, 1965), p. 12; Orienti, 1975, p. 106, no. 426

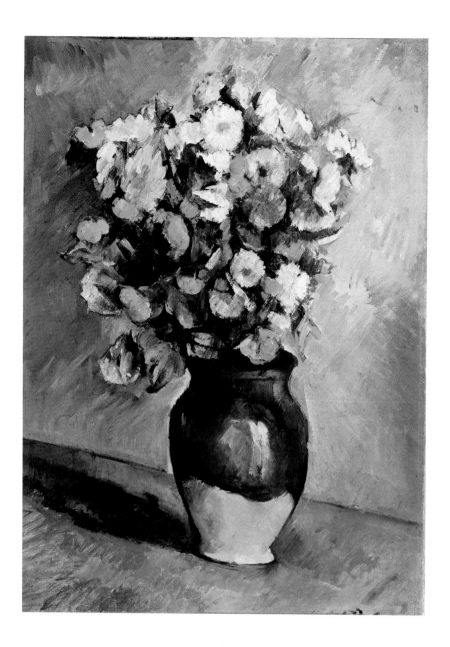

10. *FLOWERS IN AN OLIVE JAR,* c. 1880
(Fleurs dans un Pot d'Olives)

OIL ON CANVAS
18⅛ x 13³⁄₁₆″ (46 x 33.5 CM.)
PHILADELPHIA MUSEUM OF ART
MR. AND MRS. CARROLL S. TYSON, JR. COLLECTION
63-116-2

THROUGHOUT HIS CAREER Cézanne painted flowers, bouquets casually placed in a vase.
During his stay with Doctor Gachet at Auvers, he and Pissarro sometimes even painted
the same arrangement. In choosing flowers as their subjects they were following the
example of their heroes, Delacroix and Courbet, who had approached this theme with
great decorative abundance. While Venturi found the lingering influence of Courbet in
this picture, Rewald feels a more direct influence of Pissarro himself, whom Cézanne
saw often during this time.

 This picture is painted with considerable liveliness, the brushstrokes going in all
directions in a seemingly unstudied way. In the right background, the brushwork is par-

10a. Outline drawing showing areas of repaint on left
PMA. Conservation Department, Mark Tucker

10b. Detail photograph of top, center portion, showing original paint layer

NOTES:
1. Given the early date of the overpainting and the close bond of the layers, the next step of the restoration remains unclear.
2. *Kunst und Künstler* (1907), repro. p. 101; Vollard, 1919, repro. opp. p. 192.

ticularly animated, blue and white strokes taking off in a spray of angles; the left side, on the other hand, is rather leaden—timid blue-green strokes modulating only slightly and applied in a regular pattern left to right. One passage on the left, where the wall meets the tabletop in a series of upright marks, is particularly dull and it has now been discovered that this entire section of the background (fig. 10a) was overpainted by a later hand. This is clearly supported by the following evidence. During recent restoration a series of paper strips applied at the time of the relining of the canvas early in the century to protect the edge of the painting, and overlapping about a quarter of an inch onto the surface, were removed. Along the entire upper left edge and the left side of the top, the paint was on top of the paper; underneath, a darker layer continued the animated brushwork of the right side, particularly along the top of the painting (fig. 10b). Microscopic examination makes it clear that the area painted with a different technique was actually applied on top of an old varnish. It was also evident given the close bond between the new paint and the varnish that the repainting took place very early in the life of the picture.[1] This is confirmed, in fact, by reference to illustrations in publications in 1907 and more clearly in 1919, which both show the left side in its reworked state.[2]

Speculation as to why someone (perhaps Jos. Hessel, probably the first dealer to handle the picture) would have gone to the trouble to repaint the canvas leads immediately to the supposition that the painting had suffered some extreme damage. One could assume that both for the aesthetic reading of the surface as well as for reasons of marketability, extensive repainting was required. However, through infrared reflectography, it is clear that the original surface continues in fact underneath the overpainting, much of it with a vitality even exceeding that of the right-hand section. This has also been confirmed by selective cross sections taken in this area.

Since there do not seem to be technical reasons for these additions, we must assume that the later adjustments were undertaken solely for aesthetic reasons. Comparison with the infrared reflectography photograph and a similar flower painting (Venturi 511) offers a possible motivation. In that painting, as in this, the profile of the bouquet on the right is quite firm, whereas in the left section it is much more open and uncontrolled. The pentimento of one stalk of flowers lunging nearly to the edge of the Philadelphia canvas is still apparent to the naked eye, further suggesting that this entire area must have appeared too unbalanced for certain sensibilities at the beginning of this century and was simply adjusted to a more conventional (and static) composition.

PROVENANCE: Jos. Hessel, Paris, by 1910; Paul Rosenberg, Paris, by 1928; Mr. and Mrs. Carroll S. Tyson, Jr., Philadelphia; Philadelphia Museum of Art, by bequest, 1963

EXHIBITIONS: Paris, 1910, no. 28; Paris, 1924; New York, 1928, no. 2; Philadelphia, 1934, no. 22; Philadelphia, PMA, *Masterpieces of Philadelphia Private Collections* (May 1947), p. 72, no. 10; New York, 1947, no. 8

BIBLIOGRAPHY: *Kunst und Künstler* (1907), repro. p. 101; Vollard, 1919, repro. opp. p. 192; André Salmon, *Cézanne* (Paris, 1923), pl. 8; *Bulletin de la Vie Artistique* (March 1924), repro. p. 105; Léo Larguier, *Le Dimanche avec Paul Cézanne* (Paris, 1925), repro. opp. p. 112; *L'Art Vivant*, July 1, 1926, repro. p. 488; Jacques Combe, "L'Influence de Cézanne," *La Renaissance,* 19th year, nos. 5–6 (May–June 1936), repro. p. 29; Venturi, 1936, vol. 1, p. 114, no. 218, vol. 2, pl. 59, no. 218; Jewell, 1944, repro. p. 30; Irene Immerman [André Leclerc], *Cézanne* (New York, 1948), repro. p. 22; John Rewald, "The Collection of Carroll S. Tyson, Jr., Philadelphia, U.S.A.," *The Connoisseur,* vol. 134 (August 1954), repro. p. 68 (reprinted in *Philadelphia Museum of Art Bulletin,* vol. 59, no. 280 [Winter 1964], repro. p. 74); Philadelphia, PMA, *Check List of Paintings in the Philadelphia Museum of Art* (Philadelphia, 1965), p. 12; Orienti, 1975, p. 96, no. 220; Norman Turner, "Subjective Curvature in Late Cézanne," *The Art Bulletin,* vol. 63, no. 4 (December 1981), p. 667, fig. 3

11. *VIEW OF THE BAY OF MARSEILLES WITH THE VILLAGE OF SAINT-HENRI,* c. 1883
(*Saint-Henri et le Golfe de Marseille*)

OIL ON CANVAS

25⅝ x 31⅞″ (65.1 x 81 CM.)

PHILADELPHIA MUSEUM OF ART

MR. AND MRS. CARROLL S. TYSON, JR. COLLECTION

63-116-3

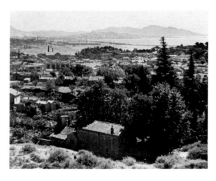

11a. *View of Saint-Henri*
Photograph by Erle Loran

THE 1914 BAEDEKER guide described the small village of L'Estaque on the bay of Marseilles, some four miles from the city, as a "favorite sea-bathing resort." However, the modern industrial sprawl that now engulfs the town completely[1] had its antecedents even earlier as is shown by the smoke billowing forth from the tile- and brickworks in the nearby village of Saint-Henri seen in this painting of about 1883. Cézanne settled in L'Estaque in May 1883, taking a house with a garden in the quartier du Château above the railroad station. The family remained there for at least a year, the artist making occasional trips to Aix (some twenty miles to the north) alone, since his father still did not officially recognize the existence of either Cézanne's mistress or his grandson.

The views from hills behind L'Estaque looking across the bay over Saint-Henri toward the promontory of Marseilleveyre with the city itself in the far distance (here indicated only by the citadel church of Notre-Dame de la Garde on a high promontory) provided some of his favorite motifs.[2] In November of 1883 Cézanne wrote to Emile Zola that his house in L'Estaque was "at the foot of the hill, the rocks with their pine trees beginning just behind us. I am completely occupied with painting. There are here beautiful views, not all of which however make for a *motif*. Nevertheless, at sunset when one climbs to the heights, there is a beautiful panorama, Marseilles and the islands in the distance, and the whole enveloped in an evening light which creates a very decorative effect."[3] While this painting hardly shows a sunset—it would appear to be mid-morning—it does richly reflect the pleasure Cézanne took from this place. The great vista is laid out with remarkable atmospheric effect and decorative unity. The round chimney and the elegantly twisting olive trees just below establish a rhythm which moves into the more richly painted middle ground; the mountains beyond are very tightly brushed in, while the sky, carefully keyed to the tones of the water, is primarily the exposed canvas ground with the most delicate washes of blue. With all its complexity of constructed planes, there is still a very vivid sense of the place as well as a subtle pictorial unity, a convincing duality often achieved by Cézanne. Indeed, when the picture is compared to photographs of this exact site (fig. 11a) taken in the late 1930s (the foreground building was still standing), one understands all the more how loyal Cézanne was to visual topography yet how completely he transformed it into his own creation.

NOTES:

1. For a modern photograph of the bay, *see Cézanne, 25 Great Masters of Modern Art,* vol. 10 (Tokyo, 1980), repro. p. 89.
2. *See* Venturi 398–99, 405, 407–8, 425–29, 492–93.
3. Rewald, 1936, p. 116 (author's translation).

PROVENANCE: Oskar Schmitz, Dresden, acquired 1912; deposited at the Kunsthalle, Basel; Wildenstein Galleries, Paris, London, New York; Mr. and Mrs. Carroll S. Tyson, Jr., Philadelphia, acquired 1937; Philadelphia Museum of Art, by bequest, 1963

EXHIBITIONS: Paris, *Salon d'Automne* (1904), no. 26; Zurich, Kunsthaus, *Sammlung Oscar Schmitz* (1932), p. 7, no. 30; Zurich, Kunsthaus, *Französische Malerei des 19. Jahrhundert* (May 14–August 6, 1933), no. 83, pl. 13; Philadelphia, 1934, no. 14a; Paris, Wildenstein & Co., *La Collection Oscar Schmitz: Chefs-d'oeuvre de la peinture française du XIXᵉ siècle* (1936), no. 10; Philadelphia, PMA, *Masterpieces of Philadelphia Private Collections* (May 1947), p. 73, no. 20; New York, 1947, p. 41, no. 23

BIBLIOGRAPHY: Vollard, 1914, pl. 44; Meier-Graefe, 1920, repro. p. 126; Karl Scheffler, "Die Sammlung Oskar Schmitz in Dresden," *Kunst und Künstler,* vol. 19 (1920–21), repro. p. 187; Meier-Graefe, 1922, repro. p. 154; Marie Dormoy, "La Collection Schmitz à Dresde," *L'Amour de l'Art* (1926), repro. p. 339; Emil Waldmann, "La Collection Schmitz," *Documents,* 2nd year, no. 5 (1930), repro. p. 317; Venturi, 1936, vol. 1, p. 154, no. 411, vol. 2, pl. 114, no. 411; Novotny, 1937, pl. 41; Novotny, 1938, p. 206, no. 111, figs. 40–41; Loran, 1946, p. 107, pl. 28; Dorival, 1948, pl. 77; Rewald, 1948, fig. 76; John Rewald, "The Collection of Carroll S. Tyson, Jr., Philadelphia, U.S.A.," *The Connoisseur,* vol. 134 (August 1954), repro. p. 65 (reprinted in *Philadelphia Museum of Art Bulletin,* vol. 59, no. 280 [Winter 1964], repro. p. 76); Philadelphia, PMA, *Check List of Paintings in the Philadelphia Museum of Art* (Philadelphia, 1965), p. 12; Orienti, 1975, p. 105, no. 420

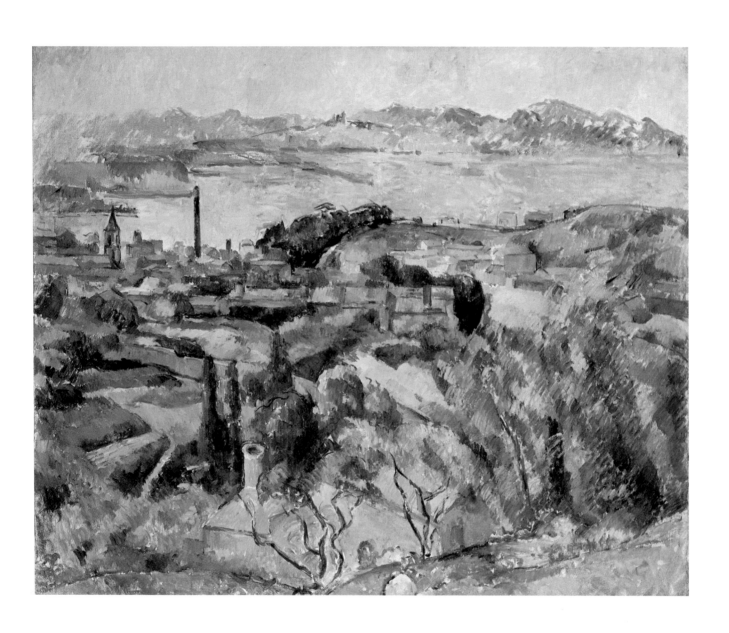

12. *PORTRAIT OF MADAME CÉZANNE, 1885–87*
(Portrait de Madame Cézanne)

OIL ON CANVAS

18¼ x 15⅛″ (46.4 x 38.4 CM.)

PHILADELPHIA MUSEUM OF ART. THE LOUIS E. STERN COLLECTION

63-181-6

LITTLE IS KNOWN of the life of Hortense Fiquet, although her oval face became one of the most repeated images in Cézanne's work, appearing in some forty-four paintings and numerous drawings as well (*see* nos. 13, 15, 23v). A tall and handsome woman with brunette hair, large black eyes, and a sallow complexion,[1] she met Cézanne in Paris in 1869, when she was nineteen years old and an artist's model. Cézanne must have felt deeply drawn to her even though he was desperately shy of women and seems to have suffered from an almost hysterical fear of physical contact.[2] It was perhaps her docile and calm temperament that encouraged him, for she became his mistress that same year. Their only child, Paul, was born in 1872; thereafter their liaison disintegrated, even though Cézanne adored the child, who would later become his primary confidante and advisor. Hortense and Paul lived apart for long periods, Hortense using her poor health

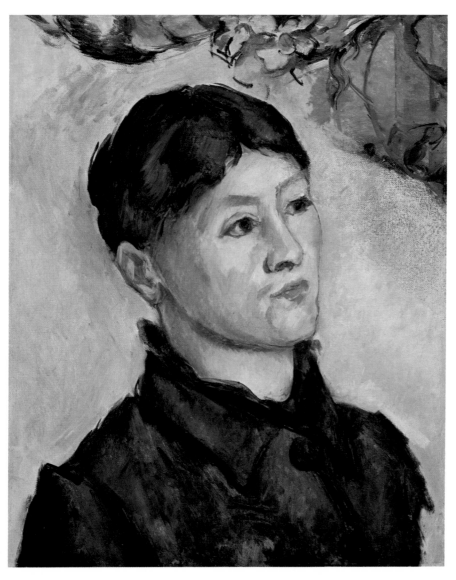

12a. Infrared reflectography video image of *Portrait of Madame Cézanne* (detail) PMA. Conservation Department, taken March 10, 1983

NOTES:

1. Rewald, 1948, p. 77.
2. This, despite the intensity of his passionate longings (most clearly stated in his correspondence with Emile Zola, a close friend of his youth).
3. Reff mistakenly assumed that these forms continue under the blue background, although they are actually on the surface and do not continue any further into the picture than can be seen with the naked eye. Reff made these observations when he saw the picture at the 1959 Wildenstein exhibition, New York. *See* Theodore Reff, "New Exhibition of Cézanne," *Burlington Magazine,* no. 684, vol. 102 (March 1960), p. 118.

as an excuse for their separation although it was clear that she much preferred Paris to the restrictive and certainly dull life of the South. Cézanne and Hortense were married in the presence of his parents in Aix in 1886, probably more to satisfy his family and legitimize the boy than for any other reason. Even when he forced her to move to Aix permanently in 1891, Cézanne arranged for a separate dwelling for her and his son while he continued to live with his mother and older sister.

Despite the intermittent coolness of their relationship, Hortense posed for him with great patience and loyalty. The dilemma of dating these images is one of the most frustrating aspects of Cézanne scholarship; despite efforts to establish her age and the date of her costume in the various portraits, no logical pattern has emerged. The variety is instead shown to be one more of mood than of physiological change, and while it has often been stated that her face became, for Cézanne, like some neutral element in a still life, there is a striking range of psychological dimension, albeit perhaps as much imposed by the restive temperament of the artist as emanating from the sitter herself.

In this well-known picture, Madame Cézanne is presented at her most alert. One can sense much of what had attracted the artist to her, and her broad and handsome brow, small, elegant ear, and wonderfully modulated jawline are realized with a tenderness rarely found in other depictions of her. This is particularly apparent in the preparatory pencil drawing of the left cheek and chin that is on the canvas under the paint, which is revealed through infrared reflectography (fig. 12a).

The curious forms at the top of the painting have prompted much speculation. For Venturi, they are the tentative blocking in of an embroidered drapery; for Reff, the remnants of a landscape in which he sees an ocher wall and green foliage.[3] It seems that Cézanne momentarily thought of placing his subject out of doors, perhaps on a terrace, backed by a vine-covered wall or trellis not unlike that of the portrait in the Metropolitan Museum of Art (Venturi 569). It is remarkable how little his abandoned additions, in their sketchy form, disturb the impact of the completely realized head. Whereas this aspect may have been the main reason for its sale by the Museum of Modern Art, the top section of the painting has become a lovely and apt embellishment, quite easily reconciled within the overall composition and chromatic harmony of the picture.

PROVENANCE: Ambroise Vollard, Paris; Auguste Pellerin, Paris; Rosenberg & Co., Paris; Dikran Khan Kelekian, Paris; Sale, Kelekian collection, New York, January 30–31, 1922, no. 112; Lillie P. Bliss, New York; Museum of Modern Art, New York, bequest; Parke-Bernet Galleries, New York, sold, May 11, 1944, no. 82; Sam Salz, New York; Louis E. Stern, New York; Philadelphia Museum of Art, by bequest, 1963

EXHIBITIONS: New York, The Metropolitan Museum of Art, *Loan Exhibition of Impressionist and Post-Impressionist Paintings* (May 3–September 15, 1921), no. 13; New York, Brooklyn Museum, *Paintings by Modern French Masters Representing the Post Impressionists and Their Predecessors* (1921), no. 24; New York, American Art Association, *Spring Salon* (1923), no. 580; New York, Academy of Arts and Sciences, "Summer Exhibition" (1926); Philadelphia, Pennsylvania Museum of Art, "Inaugural Exhibition" (1928); New York, Museum of Modern Art, *Memorial Exhibition: The Collection of the Late Miss Lizzie P. Bliss...* (May 17–September 27, 1931), no. 7; Andover, Mass., Phillips Academy, Addison Gallery of American Art, *The Collection of Miss Lizzie P. Bliss* (October 17–December 15, 1931), no. 7; Indianapolis, John Herron Art Institute, *Modern Masters from the Collection of Miss Lizzie P.*

Bliss (January 1932), p. 5, no. 7; New York, The Museum of Modern Art, *The Lillie P. Bliss Collection* (1934), pp. 25–26, no. 7; Philadelphia, 1934, no. 27; New York, Museum of Modern Art (circulating exhibition), "Twenty-Five Paintings from the Bliss Collection" (February–May 1935); Columbus, Ohio, Columbus Gallery of Fine Arts (1937); Washington, D.C., Museum of Modern Art Gallery, *Cézanne, Gauguin, Seurat, Renoir, Van Gogh* (November 15–December 2, 1937), no. 3; Detroit, The Detroit Institute of Arts, "French Impressionism from Manet to Cézanne" (May 3–June 2, 1940); Tulsa, Okla., Philbrook Art Center (1942); Richmond, Virginia Museum of Fine Arts, "Masterpieces of 19th Century Painting" (January 18–February 20, 1944); Palm Beach, Fla., Society of the Four Arts, *The French Impressionists* (February 15–March 17, 1946), no. 6; New York, 1947, p. 43, no. 27; New York, 1959, no. 30; New York, The Brooklyn Museum, *The Louis E. Stern Collection* (September 25, 1962–March 10, 1963), p. 4, no. 7; Tokyo, Musée National d'Art Occidental, *Exposition Cézanne* (March 30–May 19, 1974), no. 34

BIBLIOGRAPHY: Frank Rutter, *Revolution in Art: An Introduction to the Study of Cézanne, Gauguin, Van Gogh, and Other Modern Painters* (London, 1910), pl. 5; *Paul Cézanne, fünfzehn Autotypen* (Munich, 1912),

no. 13; Meier-Graefe, 1920, repro. p. 164; Alan Burroughs, "Making History of Impressionism," *The Arts,* vol. 1, no. 4 (April 1921), repro. p. 16; Meier-Graefe, 1922, repro. p. 196; Elie Faure, *Paul Cézanne* (Paris, 1923), pl. 11; Emile Bernard, *Sur Paul Cézanne* (Paris, 1925), repro. p. 13; Meier-Graefe, 1927, pl. 66; Pfister, 1927, fig. 73; Christian Zervos, "Idéalisme et naturalisme dans la peinture moderne. II.—Cézanne, Gauguin, Van Gogh," *Cahiers d'Art,* 2nd year, no. 9 (1927), repro. p. 338; "The New Museum of Art Inaugural Exhibition," *The Pennsylvania Museum Bulletin,* vol. 23, no. 119 (March 1928), p. 15; Anthony Bertram, "Cezanne," *The Studio* (1929), pl. 4; James Johnson Sweeney, "The Bliss Collection," *Creative Art,* vol. 8 (May 1931), repro. p. 354; Faure, 1936, pl. 34; Venturi, 1936, vol. 1, p. 177, no. 526, vol. 2, pl. 163, no. 526; *Portfolio of Twelve Paintings,* pl. 1 (reprinted from *Fortune* [December 1938]); Rosamund Frost and Aimée Crane, *Contemporary Art: The March of Art from Cézanne until Now* (New York, 1942), p. 41; Jewell, 1944, repro. p. 23; *Louis E. Stern—Collector, Philadelphia Museum of Art Bulletin,* vol. 59, no. 281 (Spring 1964), repro. 90; Orienti, 1975, p. 110, no. 520; Jean Arrouye, *La Provence de Cézanne* (Aix-en-Provence, 1982), repro. p. 70

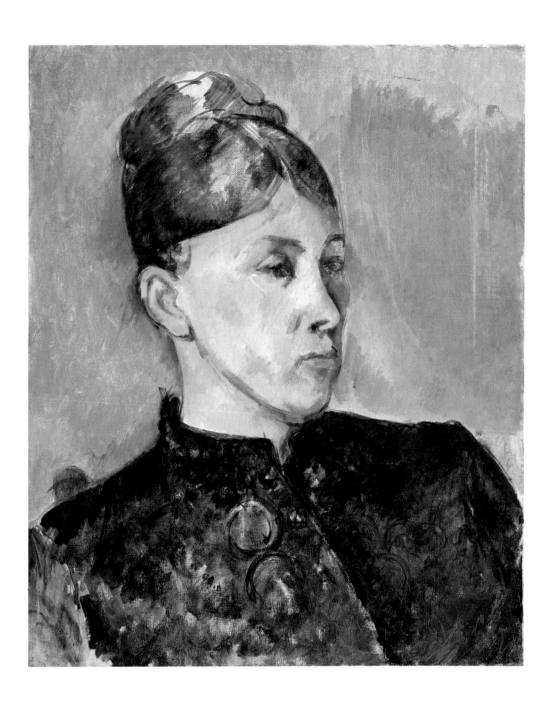

13. *PORTRAIT OF MADAME CÉZANNE, 1886–87*
(Portrait de Madame Cézanne)

OIL ON CANVAS
18⁷/₁₆ x 15⁵/₁₆″ (46.8 x 38.9 CM.)
PHILADELPHIA MUSEUM OF ART
THE SAMUEL S. WHITE, 3RD, AND VERA WHITE COLLECTION
67-30-17

OF ALL CÉZANNE's portraits of his wife, this is perhaps the most deeply satisfying. The recent cleaning has revealed afresh the remarkable boldness and deliberation with which Cézanne approached his brushwork and color. The face and neck are constructed of a series of lean, diagonal strokes with little blending of color, wet into wet; the abrupt, sculptural relationship of these tones defines the forms with breathtaking economy and

certainty. The wetter handling of the rich purple-blue dress and its brocaded pattern is more lyrical, whereas the hair, the exposed ground of the canvas acting as a tone in itself, is brushed in with thin, broad strokes. Cézanne worked the background on the left with small, regular touches, whereas he established the luminous plane to the right with a dramatic single sweep of a palette knife or perhaps even a cloth, smoothing out the texture and spatial modulation that he had laid down first.

As opposed to the previous portrait (no. 12), Madame Cézanne appears to be almost ugly in this picture. All the elements that were so appealing in the earlier work—the delicate brow, lively painted ear, and curved jawline—have now become hardened and more forceful, the uncompromising line of the jaw and the compressed lips giving her a set and rather petulant look. Here we see the masklike visage often noted in Cézanne's portraits of his wife, realized in the service of broad monumentality.

PROVENANCE: Ambroise Vollard, Paris; Henri Matisse, Nice; Paul Rosenberg, Paris; Reid & Lefevre, London; Mr. and Mrs. Samuel S. White, 3rd, Ardmore, Pa., acquired 1925; Philadelphia Museum of Art, by bequest, 1967

EXHIBITIONS: Paris, Galerie Paul Rosenberg, *Les Maîtres du siècle passé* (May 3–June 3, 1922), no. 12; Manchester, Thomas Agnew & Sons Galleries, *Loan Exhibition of Masterpieces of French Art of the 19th Century...* (1923), no. 13; New York, 1928, no. 23; Philadelphia, Pennsylvania Museum of Art, "Inaugural Exhibition" (1928); Philadelphia, Pennsylvania Museum of Art, "The White Collection" (December 9, 1933–January 10, 1934); Philadelphia, 1934, no. 44; New York, 1939, no. 7; New York, Paul Rosenberg & Co., *Loan Exhibition of Paintings by Cezanne (1839–1906) for the Benefit of Fighting France* (November 19–December 19, 1942), pp. 28, 53, no. 13; Philadelphia, PMA, *Masterpieces of Philadelphia Private Collections* (May 1947), p. 73, no. 23; New York, 1947, p. 43, no. 37; Philadelphia, PMA, "S.S. White, 3rd Collection" (1950); Chicago, 1952, p. 44, no. 44; Philadelphia, PMA, "The Samuel S. White, 3rd, and Vera White Collection" (1962–66)

BIBLIOGRAPHY: Ambroise Vollard, *Catalogue privé* (n.d.), no. 236; Elie Faure, "Toujours Cézanne," *L'Amour de l'Art* (December 1920), repro. p. 269; *Kunst und Künstler* (1920), repro. p. 397; André Fontainas and Louis Vauxcelles, *Histoire générale de l'art français de la Révolution à nos jours* (Paris, 1922), repro. p. 231; *La Renaissance*, no. 5 (1922), repro. p. 338; "The New Museum of Art Inaugural Exhibition," *The Pennsylvania Museum Bulletin*, vol. 23, no. 119 (March 1928), p. 15; *Kunst und Künstler*, vol. 27 (1928–29), repro. p. 228; Fritz Neugass, "Paul Cézanne," *Creative Art*, vol. 9, no. 4 (October 1931), repro. p. 276; Henry Clifford, "The White Collection," *The Pennsylvania Museum Bulletin*, vol. 29, no. 159 (January 1934), repro. p. 30; Erle Loran, "Cézanne at the Pennsylvania Museum," *The American Magazine of Art*, vol. 28, no. 2 (February 1935), p. 89; Rewald, 1936, fig. 58; Venturi, 1936, vol. 1, p. 176, no. 521, vol. 2, pl. 161, no. 521; James Laver, *French Painting and the Nineteenth Century* (London, 1937), pl. 117; Novotny, 1937, pl. 57; Christian Zervos, *Histoire de l'art contemporain* (Paris, 1938), repro. p. 29; *The Art News*, vol. 38, no. 6 (November 11, 1939), cover; John Rewald, *Paul Cézanne* (Paris, 1939), fig. 60; Jewell, 1944, repro. p. 40; G. Schildt, *Cézanne* (Stockholm, 1946), fig. 36; Dorival, 1948, pl. 105; Rewald, 1948, fig. 67; Dorothy Drummond, "Philadelphia News: S.S. White Collection at the Museum," *The Art Digest*, vol. 24, no. 10 (February 15, 1950), repro. p. 9; Raynal, 1954, repro. p. 72; *The Samuel S. White, 3rd, and Vera White Collection, Philadelphia Museum of Art Bulletin*, vol. 63, nos. 296–97 (January–March 1968 and April–June 1968), p. 88, no. 14; *La Chronique des Arts*, p. 83, no. 30 (supplement to *Gazette des Beaux-Arts*, 110th year, 6th ser., vol. 71, no. 1189 [February 1968]); Jack Lindsay, "Cézanne and Zola," *Art and Artists*, vol. 4, no. 6 (September 1969), repro. p. 24; Orienti, 1975, p. 110, no. 519; *Cézanne*, The World Fine Arts, vol. 13 (Tokyo, 1975), pl. 39; Venturi, 1978, repro. p. 105

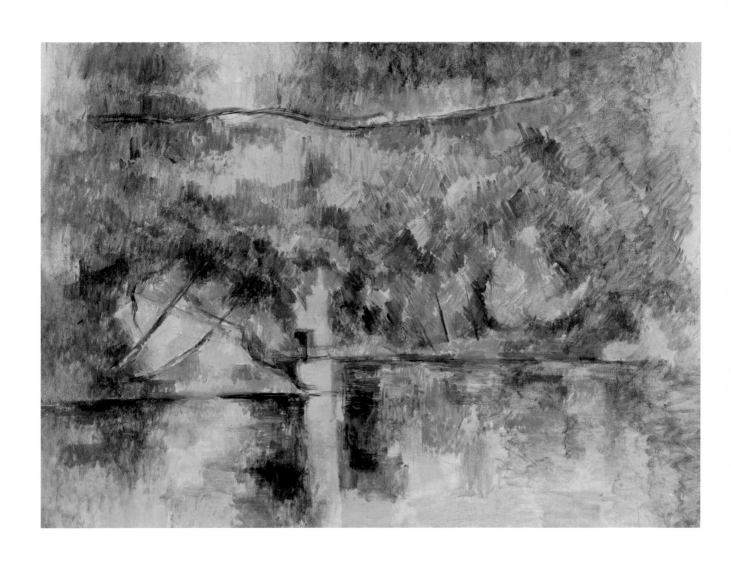

14. *EFFECT OF REFLECTIONS, 1889–90*
(Les Reflets dans l'Eau)

OIL ON CANVAS
25⅝ x 36½″ (65.1 x 92.7 CM.)
PRIVATE COLLECTION

STILL BODIES of water reflecting the surrounding trees and buildings were among the favorite subjects of the Impressionists, and one which Cézanne, in his very independent way, took up frequently during his career. Even in his earliest bathing subjects (*see* Venturi 104), the optical and spatial complexity of these inverted and reversing images held his interest and they appear in some of his masterpieces of the late 1870s and early 1880s, be it the pool at the Jas de Bouffan, the Seine near Zola's house at Médan (Venturi 325), or the little stream passing beneath the bridge at Maincy (Venturi 396). Works on this theme stand quite apart from other Cézanne landscapes, in which cast shadows and reflections are of little interest.

This painting shows an enclosed pond with high banks and a water gate in the background, suggesting that the site might be a reservoir. It is a closed and perplexing image, mysterious and more disquieting than romantic. The brushwork is made up almost entirely of light, thin strokes applied with a nervous animation and, at the upper right, a complexity of cross-hatching. It is as if the artist were reconsidering certain attitudes about handling paint—and defining forms and reflections—of the Impressionists, whom he had abandoned by the late 1870s. This led Roger Fry, in a discussion of Cézanne's "disintegration of volumes," to comment on this work: "It is quite true that in nature such a scene gives an effect of a confused interweft, but in earlier days Cézanne either would not have accepted it as a motive or would have established certain definitely articulated masses. Here the flux of small movements is continuous and unbroken. We seem almost back to the attitude of the pure Impressionists. But this is illusory, for there will be found to emerge from this a far more definite and coherent plastic construction than theirs. It is no mere impression of a natural effect, but a re-creation which has a similar dazzling multiplicity and involution."[1]

Whatever actually concerned the artist here, this experimentation with a new technique was probably inspired by his feelings for the place itself. Venturi convincingly groups this picture with another (Venturi 640) of very similar technique, which perhaps shows the same body of water with viaducts and floodgates half-hidden by trees. This sheltered place, where rather crude man-made forms are imposed on a dark glade with deep, silent water, prompted him to attempt to depict in a new manner the impalpable thinness of the air and the delicate nuance of this enclosed and remote scene.

NOTE:
1. Fry, 1929, p. 80.

PROVENANCE: Galerie Bernheim-Jeune, Paris; Marius de Zayas, New York; N. Cymbalist, Milan; Private collection, Philadelphia

EXHIBITIONS: New York, The Metropolitan Museum of Art, *Loan Exhibition of Impressionist and Post-Impressionist Paintings* (May 3–September 15, 1921), p. 5, no. 15; Aix-en-Provence, Pavillon de Vendôme, "Cézanne" (Summer 1961)

BIBLIOGRAPHY: *L'Art Vivant* (1926), p. 487; Fry, 1929, pl. 32, fig. 43; *L'Art Vivant* (1931), p. 254; Venturi, 1936, vol. 1, p. 203, no. 639, vol. 2, pl. 205, no. 639; Orienti, 1975, p. 120, no. 741

15. MADAME CÉZANNE, 1890–92
(Madame Cézanne aux Cheveux Dénoués)

OIL ON CANVAS

24⅜ x 20⅛″ (61.9 x 51.1 CM.)

COLLECTION OF HENRY P. McILHENNY, PHILADELPHIA

THE TILTED HEAD, down-turned lips, and loosened hair give this portrait a sense of sustained sadness and melancholy. Madame Cézanne has perhaps been bestowed with her husband's own spirit of deep introspection. There is a nobility to her presence in this picture that finds its closest parallels not in other portraits of her but rather among the great figures who appear in the late compositions of female bathers. Even the striped bodice, which in earlier portraits (Venturi 228–29) lends her an air of gaiety, has become sober and serious; its bands cross the picture with great stateliness. The painting has often been dated in the 1880s; however, Rewald must certainly be correct in placing it somewhat later, for it has that grace and solemnity that enters Cézanne's figurative subjects in the 1890s, felt here at its most profound.

Peter Blume has perceptively discussed the vertical line just to the left of the head, noting its irrationality as a form but its great compositional effectiveness.[1] It is possible that at some stage in the execution the line did continue below the head and down to the shoulder, to indicate a door opening or a juncture in the wall paneling. However, in adjusting the position of her right shoulder (the pentimento of the earlier outline is still somewhat visible) and the puffed top of the sleeve, the artist created a rhythmic passage that would have been interrupted by the vertical line, which it so effectively counters in this one, remarkably complex, passage of emerging and receding forms.

NOTE:

1. See Allentown, Pa., Allentown Art Museum, *French Masterpieces of the 19th Century from the Henry P. McIlhenny Collection* (May 1–September 18, 1977), p. 70.

PROVENANCE: Ambroise Vollard, Paris; Halvorsen, Oslo; Dr. J.F. Reber, Lausanne; Paul Rosenberg, Paris; Samuel Courtauld, London; Paul Rosenberg, Paris; Henry P. McIlhenny, Philadelphia

EXHIBITIONS: Paris, *Salon d'Automne* (1904), no. 3; Providence, Rhode Island School of Design, "Modern French Art" (March 11–31, 1930); Paris, Galerie Durand-Ruel, *Quelques Oeuvres importantes de Manet à Van Gogh…*(February–March 1932), no. 5; Chicago, The Art Institute of Chicago, *Catalogue of a Century of Progress Exhibition of Paintings and Sculpture Lent from American Collections* (June 1–November 1, 1934), p. 46, no. 297; Cambridge, Mass., Harvard University, Fogg Art Museum (1934); Philadelphia, 1934, no. 13; Paris, 1936, pp. 90–91, no. 58; Philadelphia, Pennsylvania Museum of Art, "French Artists of the 18th and 19th Centuries" (1937); Boston, The Institute of Modern Art [held at Museum of Fine Arts], *The Sources of Modern Painting* (March 2–April 9, 1939), p. 28, no. 13; Cambridge, Mass., Harvard University, Fogg Art Museum (1941); Philadelphia, PMA, *Masterpieces of Philadelphia Private Collections* (May 1947), p. 73, no. 21; Philadelphia, PMA, "The Henry P. McIlhenny Collection" (1949); San Francisco, The California Palace of the Legion of Honor, *The Henry P. McIlhenny Collection: Paintings, Drawings and Sculpture* (June 15–July 31, 1962), no. 1; Allentown, Pa., Allentown Art Museum, *French Masterpieces of the 19th Century from the Henry P. McIlhenny Collection* (May 1–September 18, 1977), repro. p. 71

BIBLIOGRAPHY: Ambroise Vollard, *Catalogue privé* (n.d.), no. 19; Vollard, 1914, pl. 46; Elie Faure, "Toujours Cézanne," *L'Amour de l'Art* (December 1920), repro. p. 267; Meier-Graefe, 1920, repro. opp. p. 44; Atzouji Zeisho, *Paul Cézanne* (Tokyo, 1921), pl. 2; André Fontainas and Louis Vauxcelles, *Histoire générale de l'art français de la Révolution à nos jours* (Paris, 1922), repro. p. 230; Meier-Graefe, 1922, repro. p. 129; Rivière, 1923, p. 201; Meier-Graefe, 1927, pl. 49; Pfister, 1927, fig. 72; J.B. Manson, "The Collection of Mr. and Mrs. Samuel Courtauld," *Creative Art*, vol. 4, no. 4 (April 1929), p. 262; *L'Amour de l'Art* (1929), repro. p. 17; Irene Weir, "A Cursive Review of Recent Museum Activities Outside New York," *Parnassus*, vol. 2, no. 5 (May 1930), repro. p. 25; C.J. Bulliet, *The Significant Moderns and Their Pictures* (New York, 1936), pl. 21; Venturi, 1936, vol. 1, p. 178, no. 527, vol. 2, pl. 163, no. 527; Novotny, 1937, pl. 48; Barnes, 1939, p. 412, no. 98; Raymond Cogniat, *Cézanne* (Paris, 1939), pl. 67; Dorival, 1948, pl. 107; E.H. Gombrich, *The Story of Art* (New York, 1950), p. 412, fig. 342; Schapiro, 1952, repro. p. 59; Rousseau, 1953, pl. 14; Rosamond Bernier, "Le Musée privé d'un conservateur," *L'Oeil*, no. 27 (March 1957), repro. p. 28

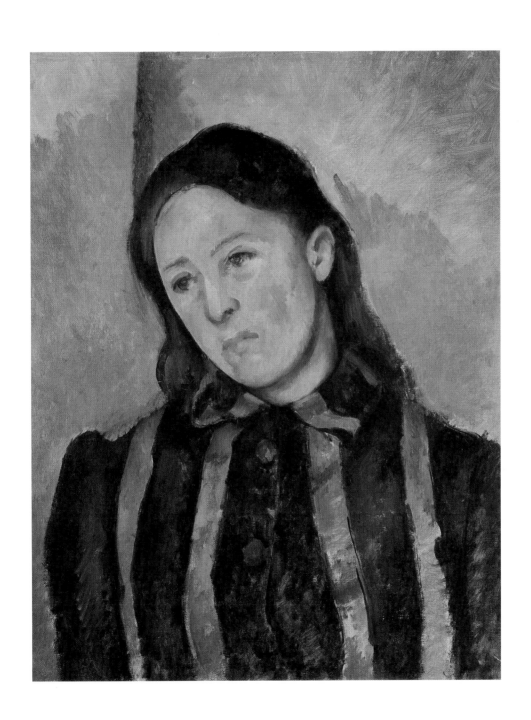

16. *THE WHITE SUGAR BOWL,* c. 1893–94
(Sucrier, Poires et Tapis)

OIL ON CANVAS
20⅛ x 24⅜″ (51.1 x 61.9 CM.)
COLLECTION OF HENRY P. McILHENNY, PHILADELPHIA

IN THE LATE 1880s Cézanne's still lifes take on a greater compositional complexity and richness, giving them an opulence new to his work in this genre. It is as if he had moved beyond the simplicity of arrangement of Chardin, whom he so deeply admired, and proceeded to reinvestigate the more agitated baroque composition of seventeenth-century Dutch painting. In this, a certain density and variety of texture is forsaken for a consistency of handling, which would develop into a greater investigation of pattern and spatial modulation. At the same time, a new set of objects appears in his modest repertory of studio props, among them a heavily woven cloth (sometimes called a drape, sometimes a rug) and, in two instances, this and a painting in Moscow (Venturi 619), a charming white faience sugar bowl with three rococo handles.

Some of these still lifes have a greatly varied and brilliant palette, whereas here Cézanne gave the dazzling white (a remarkably rare pigment in the artist's work) the weight of more aggressive color and merged the other elements—the blues and deep purple of the wall and drapery, the yellow of the pears and lemons, the green of the apples—into a rhythmic harmony of marked originality. Outstanding even within Cézanne's amazingly orchestrated *oeuvre*, the curves of the bowl's handles, the sensuous forms of the pears, and the elaborate folds in the cloth create a rhythmic pattern that would be very tempting to call "design" if it were not so fully realized in the third dimension as well as in surface intricacy.

PROVENANCE: Ambroise Vollard, Paris; J.F. Reber, Lausanne; Henry P. McIlhenny, Philadelphia

EXHIBITIONS: Berlin, Galerie Matthiesen, *Das Stilleben* (February–March 1927), no. 88; Frankfort on the Main, "Ausstellung Frankfürter Kunstverein" (October–December 1927); Philadelphia, PMA, *Masterpieces of Philadelphia Private Collections* (May 1947), p. 73, no. 37; Philadelphia, PMA, "The Henry P. McIlhenny Collection" (1949); San Francisco, The California Palace of the Legion of Honor, *The Henry P. McIlhenny Collection: Paintings, Drawings and Sculpture* (June 15– July 31, 1962), cover, no. 2; Allentown, Pa., Allentown Art Museum, *French Masterpieces of the 19th Century from the Henry P. McIlhenny Collection* (May 1–September 18, 1977), repro. p. 73

BIBLIOGRAPHY: Ambroise Vollard, *Catalogue privé* (n.d.), no. 78; Vollard, 1914, pl. 48; Gustave Coquiot, *Paul Cézanne* (Paris, 1919), repro. opp. p. 128; Meier-Graefe, 1920, repro. p. 172; Meier-Graefe, 1922, repro. p. 208; Léon Leclère [Tristan-L. Klingsor], *Cézanne* (Paris, 1923), pl. 14; Rivière, 1923, p. 173; Léon Leclère [Tristan-L. Klingsor], *Cézanne*, trans. J.-B. Manson (New York, 1924), pl. 14; Léo Larguier, *Le Dimanche avec Paul Cézanne* (Paris, 1925), repro. opp. p. 49; Elie Faure, *Paul Cézanne* (Paris, 1926), pl. 28; Pfister, 1927, fig. 80; Venturi, 1936, vol. 1, p. 200, no. 624, vol. 2, pl. 200, no. 624; Bernard Dorival, *Cézanne* (Paris, 1948), pl. 104; Dorival, 1948, pl. 100; John Canaday, *Mainstreams of Modern Art* (New York, 1959), frontis., p. 345, fig. 417; Ikegami, 1969, pl. 50; Orienti, 1975, p. 122, no. 783

17. *MILLSTONE IN THE PARK OF THE CHÂTEAU NOIR,* 1898–1900
(La Meule)

OIL ON CANVAS
29 x 36⅜″ (73.7 x 92.4 CM.)
PHILADELPHIA MUSEUM OF ART
MR. AND MRS. CARROLL S. TYSON, JR. COLLECTION
63-116-4

IN THE 1890s Cézanne, exploring the area around Aix for landscape subjects as he had done since his youth, settled on a nineteenth-century house, the Château Noir, high above the road to Tholonet, east of the city. The house and the hills surrounding it, which commanded a grand view of Mont Sainte-Victoire, became one of his favorite areas to paint. Eventually he rented a small room in the court of the château in which to store his canvases and painting equipment, and he even attempted to purchase the property.[1]

On the road leading up to the château was a cleared site for a mill that was never built, but which had tumbled piles of quarry stones and a millstone. This secluded spot, shaded from the intense sun of Provence, must have provided a sheltered place for the artist to work, particularly given his extremely considered and slow method of

painting. Its peaceful isolation must also have held great attraction for him since it provided the subject for one of his more resolved and meditative pictures. Yet this painting is remarkably loyal to the site, even as seen in a photograph taken some thirty-five years later (fig. 17a), a fidelity to motif rarely documented with greater accuracy.[2] Compared to the grand and, sometimes, panoramic views of Mont Sainte-Victoire which would begin at this time, the space is closed and contained. The dappled light allowed him to use a palette dominated by blues and purples and balanced by green and ochers (almost the tonality of twilight), which he would also employ in figurative subjects, the most dramatic comparison being the *Boy with the Skull* in the Barnes Foundation, Merion, Pennsylvania (Venturi 679). Like the theme of mortality in that picture, there is in the *Millstone* a gentle melancholy suggested by the inevitable speculation on the abandoned works of man and the power of nature to close back over them, although such speculation can lead to a sentimentality completely foreign to Cézanne's temperament. The contained scale of this picture stands in marked contrast to his panoramic late landscapes, representing with particular assurance the profound ability of the artist to encompass nature and the human condition.

NOTES:
1. *See* John Rewald, "The Last Motifs at Aix," pp. 83–106, in New York, 1977.
2. *See* John Rewald and Léo Marschutz, "Plastique et réalité: Cézanne au Château Noir," *L'Amour de l'Art*, vol. 16, no. 1 (January 1935).

PROVENANCE: Auguste Pellerin, Paris; Jean Victor Pellerin, Paris; Carroll S. Tyson, Philadelphia; Philadelphia Museum of Art, by bequest, 1963

EXHIBITIONS: London, Wildenstein & Co. Ltd., *Cézanne* (1929); London, Royal Academy of Arts, *Exhibition of French Art 1700–1900* (1932), p. 234, no. 511; Brussels, Palais des Beaux-Arts, *L'Impressionnisme* (June 15–September 29, 1935), no. 12; Paris, 1936, p. 117, no. 99, pl. 29; Philadelphia, PMA, *Masterpieces of Philadelphia Private Collections* (May 1947), p. 85, no. 44; New York, 1947, p. 62, no. 62; Philadelphia, PMA, *Diamond Jubilee Exhibition: Masterpieces of Painting* (November 4, 1950–February 11, 1951), no. 87

BIBLIOGRAPHY: Rivière, 1923, p. 223; Amédée Ozenfant, *Art* (Paris, 1928), repro. p. 56; John Rewald and Léo Marschutz, "Plastique et réalité: Cézanne au Château Noir," *L'Amour de l'Art,*

vol. 16, no. 1 (January 1935), p. 17, fig. 6; René Huyghe, "Cézanne et son oeuvre," *L'Amour de l'Art* (May 1936), p. 184, fig. 74; Faure, 1936, pl. 53; Venturi, 1936, vol. 1, p. 230, no. 768, vol. 2, pl. 254, no. 768; Barnes, 1939, p. 419, no. 165; Jan Gordon, "Common Sense and Contemporary Art," *The Studio* (January 1944), repro. p. 4; *Artist*, vol. 31 (July 1946), p. 105; Bernard Dorival, *Cézanne* (Paris, 1948), pl. 136; Dorival, 1948, pl. 132; Schapiro, 1952, repro. p. 121; Rousseau, 1953, pl. 24; John Rewald, "The Collection of Carroll S. Tyson, Jr., Philadelphia, U.S.A.," *The Connoisseur,* vol. 134 (August 1954), repro. p. 65 (reprinted in *Philadelphia Museum of Art Bulletin,* vol. 59, no. 280 [Winter 1964], repro. p. 56); Ikegami, 1969, p. 106, no. 30; Miura, 1972, pl. 51; Brion, 1974, repro. p. 80; Yusuke Nakahara, *Cézanne* (Tokyo, 1974), pl. 25; Orienti, 1975, p. 118, no. 702; New York, 1977, p. 251, pl. 47; *Cézanne, 25 Great Masters of Modern Art,* vol. 10 (Tokyo, 1980), pl. 56

17a. *Millstone in the Park of the Château Noir* Photograph by John Rewald

18. LANDSCAPE, 1894
(Paysage d'Hiver, Environs de Paris)

OIL ON CANVAS

25⅝ x 31⅞" (65.1 x 81 CM.)

PHILADELPHIA MUSEUM OF ART. GIFT OF FRANK AND ALICE OSBORNE

66-68-3

THIS UNFINISHED PAINTING has often troubled scholars of Cézanne; it has been dated from 1878 (Rivière) to the mid-1880s (Venturi), and some have doubted its authenticity (although never in print). Rewald, however, has firmly established it as a work of 1894 and discovered its history.

In the autumn of 1894, Cézanne accepted Monet's invitation to visit him in the village of Giverny on the Seine, some forty-five miles northwest of Paris, where Monet had settled in 1883. Cézanne stayed in an inn, the Hotel Baudy, and seems at least for a while to have graciously accepted the hospitality that his friend arranged for him. During the month of September a number of visitors came out from Paris—the painter Mary Cassatt, the politician (later premier) Georges Clemenceau, the poet Gustav Mirabeau, and the sculptor Auguste Rodin. As Gustave Geffroy, who was also among the guests, described these encounters, the shy and awkward Cézanne was remarkably appreciative and sociable, even becoming extremely emotional when Rodin honored him with a shake of the hand.[1]

However, Cézanne's touchiness and fear of those even most sympathetic to him soon emerged. At a special gathering of artists, including Renoir and Sisley, when Monet greeted him with the words, "At last we are here all together and are happy to seize this occasion to tell you how fond we are of you and how much we admire your art," the dismayed Cézanne stared at him and answered, "You, too, are making fun of me," and then turned and left the room.[2]

Shortly thereafter Cézanne left the village without telling Monet, abandoning several canvases, which Monet eventually gathered up and sent to him in Aix. It was the last time the two artists would meet, although a letter to Monet from Aix the following July stands as a touching document of Cézanne's own knowledge of his violent temperament: "So here I am back again in the South, which I ought, perhaps, never to have left to fling myself once more into the chimerical pursuit of art....May I tell you how grateful I was for the moral support I found in you which served as a stimulus for my painting....I greatly regret having left without seeing you again...."[3]

Other works from the Giverny visit have not been traced, although a Barnes Foundation painting, *House and Trees* (Venturi 646), may also have been executed in

18a. Page (detail) from the Registry of the Hotel Baudy, Giverny
Entry 410: Cézanne arrived September 7, 1894; departed September 30, 1894
PMA

Nº D'ORDRE	NOMS ET PRÉNOMS DES VOYAGEURS	AGE	QUALITÉS OU PROFESSIONS	LIEU DE NAISSANCE	DEMEURE HABITUELLE		DATE DU PASSEPORT	LIEU OU IL A ÉTÉ DÉLIVRÉ	LIEU D'OU ILS VIENNENT	LIEU OU ILS VONT	DATES D'ARRIVÉE	DATES DE DÉPART	VISA DE M. LE COMMISSAIRE DE POLICE
403	Puiotte	21		San Francisco	8 Bd Montparnasse Paris				Paris		20 7 94	29 8 94	
404	Lessier		Etudiants	Etats Unis d'Amérique					Hollande	Paris par Liège et Belvue	3 8 94	10 1 94	
405	Pulsifer Le	21			Paris U.S.						3 8 94	10 9 94	
406	G. Hutchinson	28									3 8 94	9 1 94	
407	Kaminsky			Ambroise Chatel	Paris et Barbizon				Paris		4 8 94	19 8 94	
408	M. F. Prizotto				9 rue de Jaumy				Hollande		4 8 94	18 8 94	
409	M. Jones										4 8	19 7 94	
				brigade de Gendarmerie d'Eros à Giverny		2 novembre 1894	Paris						
410	M. Cézanne P	17	artiste peintre	Aix	Paris Eau P. Baudy				Paris		7 8 94	30 9 94	

NOTES:

1. *See* Gustave Geffroy, *Claude Monet: Sa Vie, son temps, son oeuvre* (Paris, 1922), pp. 196–99. *See also* Rewald, 1948, pp. 165–67.

2. *Ibid.*, p. 167.

3. Cézanne, 1941, p. 196.

PROVENANCE: Mme Baudy, Giverny; Frank C. Osborne, Dobbs Ferry, N.Y.; Alice Newton Osborne, Manchester, Vt.; Philadelphia Museum of Art, by gift, 1966

EXHIBITIONS: None

BIBLIOGRAPHY: Rivière, 1923, p. 206; Georges Rivière, *Cézanne, le peintre solitaire* (Paris, 1933), repro. p. 65; Georges Rivière, *Cézanne* (Paris, 1936), repro. p. 69; Venturi, 1936, vol. 1, p. 160, no. 440, vol. 2, pl. 128, no. 440; Orienti, 1975, p. 102, no. 347

the village. According to Rewald, the view of the village painted here is taken near the Hotel Baudy looking out onto an enclosed orchard. This picture was not among those works that Monet sent to Aix, since its provenance can be traced back to Madame Baudy, the owner of the inn. A registry of the hotel now in the Philadelphia Museum of Art (fig. 18a) lists Cézanne as a guest from September 7 until September 30 and further confirms his stay there and gives a tighter date for the picture.

With the knowledge now that this is an unfinished and abandoned work, this painting provides considerable insight into Cézanne's working methods in the 1890s. With the exception of the sky—which is quickly washed in blue or left as bare ground—all the elements are blocked in with a consistent brushstroke, using the white of the ground as a color equal to a painted area. The forceful recession of the trees is firmly established already. The balance and unity of drawing and painting are markedly more evident here, in a painting at a skeletal level, than elsewhere, and demonstrate how completely melded these two elements have become for the artist, for example, in the wonderful way the lyrically bending branches of the central tree are defined in part by the painting of the wall beyond.

19. *GROUP OF BATHERS*, c. 1895
(Groupe de Baigneurs)

OIL ON CANVAS
8⅛ x 12⅛″ (20.6 x 30.8 CM.)
PHILADELPHIA MUSEUM OF ART
THE LOUISE AND WALTER ARENSBERG COLLECTION
50-134-AI-34

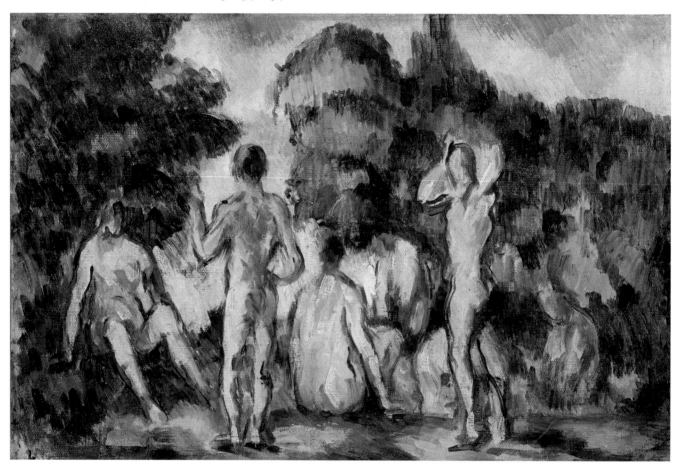

THE PRESENTATION of nude bathers in a landscape is one of the noblest themes in the history of Western art. With its origins in antiquity, it evolved through great masterpieces by Botticelli, Titian, Poussin, and Boucher. Cézanne, through his numerous explorations of this subject on canvas and paper (some two hundred are known), brought it to a new level of resolution, and carried it heroically into our century.

In Cézanne's treatment of the theme, there is a general easing over time of its specific erotic content and with it, identifiable narrative allusions. The pattern—and it has numerous exceptions—seems also to move at a quite different chronology within the two types of bather subjects, those with male figures and those showing female nudes. The first of these finds its fullest statement in three masterworks: *Bathers in Repose* in the Barnes Foundation (Venturi 276), the standing male figure in the Museum of Modern Art (Venturi 548), and the *Bathers* in the Louvre (Venturi 580). All seem to harken back to idyllic memories of his youth in Provence, time spent happily in long summer hours swimming and sunning with his friends Emile Zola and Baptistin Baille in the countryside. These images, which are found in the early sketchbooks and recur throughout Cézanne's career, are tempered by and blended with his academic drawing exercises of the male nude (either from the model or after sculpture) and his fascination with certain treatments of nudes by earlier masters, specifically copies after Michelangelo's lost cartoon of the battle of Cascina and the drawings of Signorelli.

This small painting, with two standing and five seated figures, falls within a group of similar studies dated from the 1890s and into the new century, the Louvre picture being the largest of this type (although not necessarily either the earliest or the conclusion of the series). The figures form a simple and harmonious frieze against a barrier of trees; the standing figures, who appear in similar poses in all the versions, have the grace and considered contrapposto of models holding established poses after the antique, whereas the other figures, either seated on the bank or swimming in the river, are more candidly observed. Through the simple and direct working of color, the picture is realized with a strong sense of relief and yet without stylistic pretensions or psychological or sensual complexity. These improvisations would provide the foundations for his more ambitious dealings with the nude: the large compositions of female bathers, which are the culmination of his career. As Rewald observes: "It was here, in canvases of more modest dimensions, that he could improvise more readily and give freer rein to his imagination and his sense of rhythm and movement."[1]

NOTE:
1. John Rewald, "Catalog," pp. 398–99, in New York, 1977.

PROVENANCE: Galerie Barbazanges, Paris; Walter C. Arensberg, Hollywood; Philadelphia Museum of Art, 1950

EXHIBITIONS: New York, The Metropolitan Museum of Art, *Loan Exhibition of Impressionist and Post-Impressionist Paintings* (May 3–September 15, 1921), p. 5, no. 12; San Francisco, The California Palace of the Legion of Honor, *Exhibition of French Painting from the Fifteenth Century to the Present Day* (June 8–July 8, 1934), p. 45, no. 69; San Francisco, San Francisco Museum of Art, *Paul Cézanne: Exhibition of Paintings, Water-Colors, Drawings and Prints* (September 1–October 4, 1937), no. 30; New York, The Metropolitan Museum of Art, *French Painting from David to Toulouse-Lautrec. Loans from French and American Museums and Collections* (February 6–March 26, 1941), p. 2, no. 5, fig. 47; Chicago, The Art Institute of Chicago, *20th Century Art. From the Louise and Walter Arensberg Collection* (October 20–December 18, 1949), p. 26, no. 38

BIBLIOGRAPHY: Hans von Wedderkop, "Paul Cézanne," *Der Cicerone*, vol. 14, no. 16 (1922), repro. p. 685; von Wedderkop, 1922, repro.; DeWitt H. Parker, *The Analysis of Art* (New Haven, 1926), fig. 19; Venturi, 1936, vol. 1, p. 192, no. 591, vol. 2, pl. 190, no. 591; Philadelphia, PMA, *The Louise and Walter Arensberg Collection: 20th Century Section* (Philadelphia, 1954), no. 33; *Art News Annual*, vol. 24 (1955), p. 177; Philadelphia, PMA, *Check List of Paintings in the Philadelphia Museum of Art* (Philadelphia, 1965), p. 12; Ikegami, 1969, pl. 66; Orienti, 1975, p. 115, no. 644

20. MONT SAINTE-VICTOIRE, 1902-4
(La Montagne Sainte-Victoire)

OIL ON CANVAS

27½ x 35¼" (69.8 x 89.5 CM.)

PHILADELPHIA MUSEUM OF ART. THE GEORGE W. ELKINS COLLECTION

E36-1-1

IN 1902 CÉZANNE moved into a studio building, which he had built in the hills north of Aix, called Les Lauves, where he would paint some of the grandest works of the last years of his life. In 1899 he had been forced, through the settlement of his mother's estate, to give up the large house of his childhood, the Jas de Bouffan, and since then had been living and working in an apartment in the city. The new studio allowed him to consider again works on a grand scale, such as *The Large Bathers*, but also brought him in constant view of one of his favorite subjects, the distant, dramatic Mont Sainte-Victoire and the plain spread out before it. His repetitions of this view over the next four years, seen from slightly different angles and with varying emphasis on elements in the foreground, make up a series of great magnitude, which, more than any other image created by Cézanne, has become his hallmark.

Novotny has suggested that in these late views of Mont Sainte-Victoire, Cézanne abandoned the serenity and quiet of his landscapes of the 1890s and returned to the impassioned spirit of his works of the 1860s and early 1870s. He speaks of the ecstatic excitement of the handling, the presence of "a dominant coloration," the "violent and deep-plunging...structure."[1] This landscape perhaps best supports Novotny's observations. The picture is divided into abrupt bands, which recede in mighty procession across the vast panorama. The foreground is made up of dark, purple-blue strokes, the plane beyond, of a complex perspective formed by the group of ocher houses on the left; the third plane is a dense working of ocher and sharper greens—placed with great vigor across the surface—which leads to the blue, racing line forming the platform of the granite mountain. Here the color changes completely, the ochers giving way to vermilion, the blues lifting into lavenders and lighter purples—all animated still more by the intense ultramarine blue that defines the planes of the mountain and yet is as much a part of its spatial definition as a description of the outline of its massive form. As if Cézanne had witnessed a passing storm, the sky moves from dense blues and greens on the left to more feathery and paler hues on the right and with more white of the ground showing through. But, perhaps to balance the great form of the peak, a lovely pink cloud, edged with pale green, drifts beside it.

This is an exultant work of brilliance and august grandeur; yet for all its titanic energy, there is no sense of excess or self-indulgence. While we may share fully in the emotional exuberance of its creation, the formal resolution and absoluteness of this image continue to awe.

NOTE:
1. Fritz Novotny, "The Late Landscape Paintings," p. 110, in New York, 1977.

PROVENANCE: Ambroise Vollard, Paris; Paul Rosenberg, Paris; Philadelphia Museum of Art, purchased, 1936

EXHIBITIONS: New York, Paul Rosenberg & Co., *Loan Exhibition of 21 Masterpieces by 7 Great Masters*...(November 15–December 18, 1948), pp. 24–25, no. 3; Philadelphia, PMA, *Diamond Jubilee Exhibition: Masterpieces of Painting* (November 4, 1950–February 11, 1951), no. 89; Chicago, 1952, p. 90, no. 109; Paris, Musée de l'Orangerie, *De David à Toulouse-Lautrec: Chefs-d'oeuvre des collections américaines* (1955), cat. no. 6, pl. 67; The Hague, Gemeentemuseum den Haag, *Paul Cézanne, 1839–1906* (June–July 1956), cat. no. 56; Munich, Haus der Kunst München, *Paul Cézanne, 1839–1906* (October–November 1956), cat. no. 66; Brussels, Palais International des Beaux-Arts, *Exposition universelle et internationale de Bruxelles; 50 ans d'art moderne* (April 17–October 19, 1958), repro. p. 90, p. 297, cat. no. 53; New York, 1959, no.

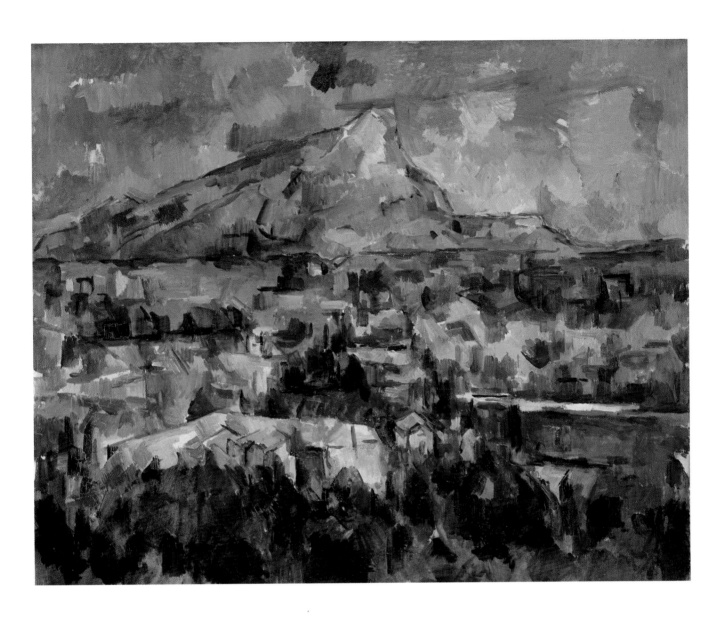

54; New York, Wildenstein, *Olympia's Progeny: French Impressionist and Post-Impressionist Paintings (1865–1905)* (October 28–November 27, 1965), no. 81; New York, 1977, p. 315, pl. 122, p. 404, cat. no. 58; Paris, 1978, pp. 191–94, no. 82

BIBLIOGRAPHY: "Accessions," *The American Magazine of Art,* vol. 29, no. 8 (August 1936), repro. p. 535; Rewald, 1936, pl. 77; Venturi, 1936, vol. 1, p. 235, no. 798, vol. 2, pl. 263, no. 798; "La Vie artistique à l'étranger," *La Revue de l'Art,* 3rd ser., vol. 70 (1936), repro. p. 143; *Sixty-First Annual Report of the Pennsylvania Museum of Art...*(1937), repro. opp. p. 12; *Portfolio of French Painting, The Pennsylvania Museum Bulletin,* vol. 32, no. 176 (January 1938), repro.; Barnes, 1939, repro. p. 281; Helen F. Mackenzie, *Understanding Picasso: A Study of His Styles and Development* (Chicago, 1940), pl. 7; *Handbook of the Museum, The Philadelphia Museum Bulletin,* vol. 37, no. 193 (March 1942), repro. p. 27; Loran, 1946, p. 104, pl. 26; John Rewald, *The History of Impressionism* (New York, 1946), repro. p. 427; *The College and the Museum, The Philadelphia Museum Bulletin,* vol. 43,

no. 218 (May 1948), repro. p. 58; Rewald, 1948, fig. 105; John Canaday, *Mainstreams of Modern Art* (New York, 1959), p. 355, fig. 430; Herbert Read, *A Concise History of Modern Painting* (London, 1959), repro. p. 15; Werner Haftmann, *Painting in the Twentieth Century* (New York, 1960), vol. 2, repro. p. 41; Johannes Itten, *The Art of Color: The Subjective Experience and Objective Rationale of Color,* trans. Ernst van Haagen (New York, 1961), p. 85, pl. 15; Naum Gabo, *Of Divers Art* (New York, 1962), p. 168, no. 67; *Perspecta,* vol. 8 (1963), p. 46; Philadelphia, PMA, *Check List of Paintings in the Philadelphia Museum of Art* (Philadelphia, 1965), p. 12; Riccardo Barletta et al., *L'Arte moderna,* vol. 1, *Realtà e forma nel postimpressionismo* (Milan, 1967), repro. p. 149; George Heard Hamilton, *Painting and Sculpture in Europe, 1880 to 1940* (Baltimore, 1967), pl. 9B; Ellen H. Johnson, *Paul Cézanne* (Paulton near Bristol, Eng., 1967), pls. 14–15; Alberto Martini and Renata Negri, *Cézanne e il post-impressionismo* (Milan, 1967), p. 34, pl. 8; *Cézanne and the Post-Impressionists* (Milan, 1970), p. 26, pl. 8; Miura, 1972, pl. 15; Rewald, 1973, repro. p. 579; Brion, 1974,

repro. p. 67; Yusuke Nakahara, *Cézanne* (Tokyo, 1974), pl. 29; *Cézanne*, The World Fine Arts, vol. 13 (Tokyo, 1975), pl. 69; Orienti, 1975, p. 121, no. 760; Nicholas Wadley, *Cézanne and His Art* (London, 1975), pl. 72; Edward B. Henning, "Picasso: Harlequin with Violins (Si Te Veux)," *The Bulletin of the Cleveland Museum of Art,* vol. 63, no. 1 (January 1976), p. 8, fig. 13; Yasuo Kamon and Kawakita Michiaki, eds., *Cézanne* (Tokyo, 1976), pl. 44; Robert Hughes, "The Triumph of the Recluse," *Time*, October 17, 1977, repro. pp. 84–85; Georges A. Embirico, "Cézanne et la répétition," *Connaissance des Arts,* no. 315 (May 1978), repro. p. 71; Venturi, 1978, repro. p. 140; *Cézanne*, 25 Great Masters of Modern Art, vol. 10 (Tokyo, 1980), pl. 59; Robert Hughes, *The Shock of the New: Art and the Century of Change* (London, 1980), p. 19, pl. 2; Jean Arrouye, *La Provence de Cézanne* (Aix-en-Provence, 1982), pp. 96–97

21. *MONT SAINTE-VICTOIRE,* 1902–6
(*La Montagne Sainte-Victoire*)

OIL ON CANVAS
25½ x 32″ (64.8 x 81.3 CM.)
PRIVATE COLLECTION. PARTIAL GIFT TO THE PHILADELPHIA MUSEUM OF ART
1977-288-1

BY CONTRAST with the previous painting (no. 20) taken from almost the same viewpoint at Les Lauves, this landscape is both more highly pitched in its execution and more lyrical in its effect. Most of the individual forms in the foreground are indicated by brushstrokes of fluid richness, which bring them close to the edge of abstraction. Colors overlap in complex glazes and scumbles, not in a wet into wet technique but brushed one over the other after the undertone dried. This created areas of color that emphasize the surface plane rather than the depth of the vista, as in the more spatially aggressive working of the previous landscape with its discrete placement of separate colors. Certain tones are allowed to gather in greater masses, such as the green foliage and the yellow line on the right. The peak of the mountain has lost its sharpness, and is more gently rounded as it crests and falls away to the south. The sky, wonderfully animated by fully loaded but lightly laid-on strokes that go in all directions, takes on an overall decorative quality absent in the other landscape.

A comparison of these two great works underscores yet again the remarkable range, both emotional and stylistic, of Cézanne, who within one subject can give quite distinct readings of man's response to nature. His effort seems all the more impressive when it is realized that he was considering simultaneously with the creation of these landscapes a quite different set of concerns, drawn more from imagination and art than the view from his studio, the series of "Large Bathers."

PROVENANCE: Ambroise Vollard, Paris; Mr. and Mrs. Carroll S. Tyson, Jr., Philadelphia; Private collection, Philadelphia; Philadelphia Museum of Art, partial gift, 1977

EXHIBITIONS: Philadelphia, PMA, *Masterpieces of Philadelphia Private Collections* (May 1947), p. 74, no. 51; Chicago, 1952, p. 91, no. 110; New York, 1977, p. 314, pl. 121, p. 405, cat. no. 59

BIBLIOGRAPHY: Venturi, 1936, vol. 1, p. 235, no. 799, vol. 2, pl. 263, no. 799; Schapiro, 1952, repro. p. 125; Miura, 1972, pl. 54; Orienti, 1975, p. 121, no. 761; Paris, 1978, p. 201, no. 86; Norman Turner, "Subjective Curvature in Late Cézanne," *The Art Bulletin*, vol. 63, no. 4 (December 1981), p. 668, fig. 6

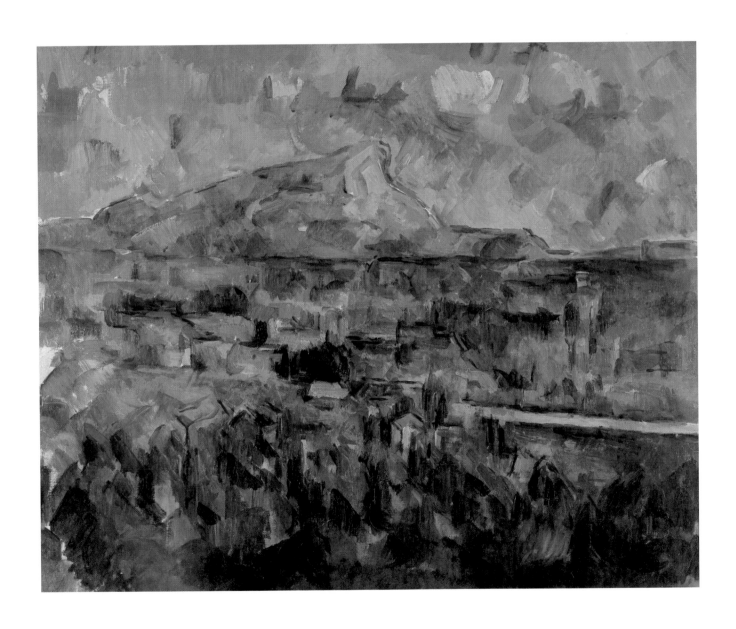

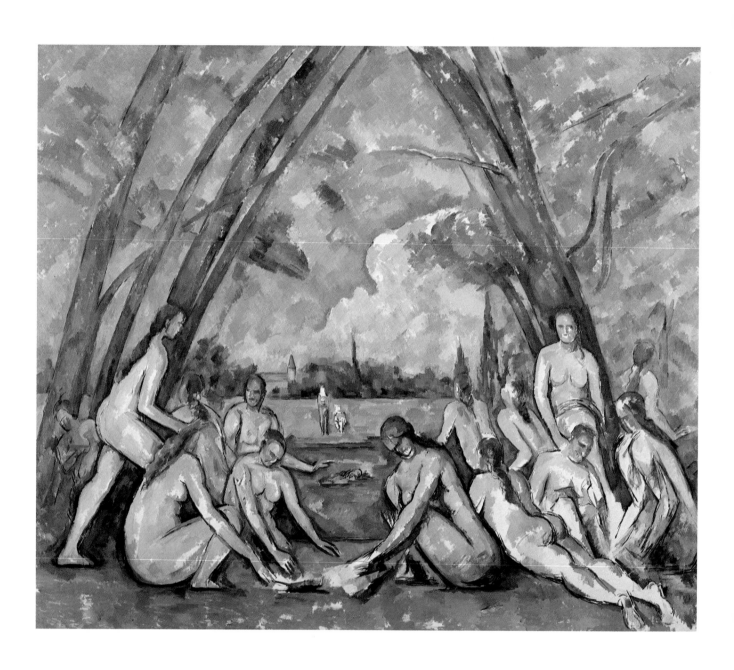

22. THE LARGE BATHERS, 1906
(Les Grandes Baigneuses)

OIL ON CANVAS

82 x 99″ (208.3 x 251.5 CM.)

PHILADELPHIA MUSEUM OF ART. PURCHASED: THE W.P. WILSTACH COLLECTION

W37-1-1

HENRY MOORE REMEMBERS his first impression of this picture in 1921: "We did go to see the Pellerin collection and what had a tremendous impact on me was the big Cézanne, the triangular bathing composition with the nudes in perspective, lying on the ground as if they'd been sliced out of mountain rock. For me this was like seeing Chartres Cathedral."[1]

The impact of this grand and monumental work has ranked it, in nearly all writings on Cézanne, as both his single most ambitious painting and his culminating masterwork. With its two large variations, in the National Gallery, London, and the Barnes Foundation in Merion, Pennsylvania, it stands as a summation of his beliefs at the end of his life and as one of the major achievements in the history of art.

Much has been written about this picture and the two, somewhat smaller, closely related versions, and yet its essential dignity has yet to be fully explicated. The theme is one that preoccupied Cézanne throughout his career and which he certainly conceived, especially here, as a work in the grandest tradition of museum pictures. The great monumental forms in the foreground, framed by the vaulted arch of trees, have led many to apply architectural analogies as effectively as the language of painting in their attempts to express their feelings about it. The coloration—primarily blues and greens, with a great deal of the primed canvas left exposed—applied with a deliberate, almost watercolor, technique of separate, measured strokes, sets it quite apart from the other versions, which are very heavily worked and extremely dense and vigorous in handling.

Rewald's speculation that this was the last of the series, taken up only a few months before the artist died (and probably left unfinished), is particularly persuasive in explaining both the sparsity of the application and the more harmonious grouping of the figures and their placement in the landscape.[2] The serenity and resolution here are unlike the mood of the other two, in which the figures and their relationship to the landscape are given both a sensuous power and a psychological tension. The very late dating may also explain, in turn, the absence of the specific allusions seen in the two variations: a picnic still life, a black dog being patted by one of the nudes. Instead, Cézanne added in the immense space created by the grand arch of the trees, new figurative elements: the charming swimmer in the center ground and the two figures resting on the opposite bank.[3]

NOTES:

1. Henry Moore, *Henry Moore on Sculpture*, ed. Philip James (London, 1966), p. 190.

2. *See* John Rewald's discussion of the London version in Paris, 1978, pp. 214–21, no. 96. The first known mention of the Philadelphia painting is by the German connoisseur Karl Ernst Osthaus, who visited Cézanne at Les Lauves in April 1906 and described a bathing subject with a vaulted perspective of trees ("Cézanne," *Das Feuer*, vol. 2 [1920–21]). The painter Maurice Denis, who was there earlier the same year (in January), mentions a bather subject begun before Cézanne's return to Aix—probably a reference to his last working trip to Paris in 1898—and therefore he saw either the Barnes or London picture, but not Philadelphia's (*Journal*, vol. 2, *1905–1920* [Paris, 1957], p. 29). If the Philadelphia painting had been begun at that point, Denis would surely have seen it, for the studio was too small for a picture of its size to be put away out of sight.

3. These have been variously interpreted, most recently as fishermen (*see* Sidney Geist, "The Secret Life of Paul Cézanne," *Art International*, vol. 19, no. 9 [November 20, 1975], pp. 7–10); however, they seem to be simply two more female nudes, one standing, the other on her back, painted with a remarkably effective frontal foreshortening.

PROVENANCE: Ambroise Vollard, Paris; Auguste Pellerin, Paris; J.V. Pellerin, Paris; with Wildenstein & Co., New York; Philadelphia Museum of Art, purchased, 1937

EXHIBITIONS: Paris, *Salon d'Automne, Rétrospective d'oeuvres de Paul Cézanne* (1907), no. 19; Berlin, *XV Ausstellung der Berliner Sezession* (1908), no. 40; Paris, Galerie Bernheim-Jeune, *Exposition rétrospective Paul Cézanne* (June 1–30, 1926), no. 107; Paris, 1936, pp. 122–23, cat. no. 107, pl. 18; Philadelphia, PMA, *Diamond Jubilee Exhibition: Masterpieces of Painting* (November 4, 1950–February 11, 1951), no. 88; Chicago, 1952, p. 81, no. 95; Paris, Musée de l'Orangerie, *De David à Toulouse-Lautrec: Chefs-d'oeuvre des collections américaines* (1955), cat. no. 5, pl. 63

BIBLIOGRAPHY: R. Schmidt, *Kunst*, July 1, 1910, p. 437; Julius Meier-Graefe, *Paul Cézanne* (Munich, 1912), no. 3; Wassily Kandinsky, *The Art of Spiritual Harmony*, trans. M.T.H. Sadler (Boston, 1914), repro. opp. p. 60; Max Raphael, *Von Monet zu Picasso...* (Munich, 1919), fig. 30; Fritz Burger, *Cézanne und Hodler* (Munich, 1920), pl. 59; Max Deri, *Die Malerei im XIX Jahrhundert* (Berlin, 1920), pl. 51; Meier-Graefe, 1920, repro. p. 203; *L'Amour de l'Art* (1921), repro. p. 331; Joachim Gasquet, *Cézanne* (Paris, 1921), repro. opp. p. 35; Atzouji Zeisho, *Paul Cézanne* (Tokyo, 1921), pl. 26;

22a. Paul Cézanne
Bathers
Oil on canvas, 52⅜ x 81½″
© Barnes Foundation, Merion, Pa.

22b. Paul Cézanne
Bathers
Oil on canvas, 51¼ x 76¾″
National Gallery, London

André Fontainas and Louis Vauxcelles, *Histoire générale de l'art français de la Révolution à nos jours* (Paris, 1922), repro. p. 233; Léon Leclère [Tristan-L. Klingsor], *Cézanne* (Paris, 1923), pl. 33; Rivière, 1923, p. 223; Léon Leclère [Tristan-L. Klingsor], *Cézanne,* trans. J.-B. Manson (New York, 1924), pl. 33; *L'Art Vivant,* March 1, 1925, repro. p. 22; Jacques Mauny, "Paris Letter," *The Arts,* vol. 10, no. 2 (August 1926), repro. p. 118; *L'Amour de l'Art* (1926), repro. p. 415; Ikouma Arishima, "Cézanne," *Ars,* vol. 14 (1926), pl. 49; *L'Art Vivant* (1926), repro. p. 482; Joachim Gasquet, *Cézanne,* new ed. (Paris, 1926), repro.; Meier-Graefe, 1927, pl. 104; Julius Meier-Graefe, *Entwicklungsgeschichte der modernen Malerei* (Munich, 1927), vol. 3, repro. p. 503; Anthony Bertram, *The World's Masters: Cézanne* (London, 1929), pl. 11; Fry, 1929, pl. 34, fig. 45; Robert Rey, *La Renaissance du sentiment classique...*(Paris, 1931), repro. opp. p. 92; André Lhote, *La Peinture, le coeur et l'esprit* (Paris, 1933), repro. p. 160; Gerstle Mack, *Paul Cézanne* (New York, 1935), pl. 33; *L'Art Sacre* (May 1936), fig. 27; René Huyghe, "Cézanne et son oeuvre," *L'Amour de l'Art,* vol. 17, no. 5 (May 1936), p. 187, fig. 81; Charles Sterling, "Cézanne et les maîtres d'autrefois," *La Renaissance,* nos. 5–6 (May–June 1936), p. 9, fig. 4; Faure, 1936, no. 58; Maurice Raynal, *Cézanne* (New York, 1936), p. 136, pl. 101; Venturi, 1936, vol. 1, p. 220, no. 719, vol. 2, pl. 236, no. 719; "Cézanne's Great 'Bathers' Comes to America: Another Philadelphia Event," *The Art News,* vol. 36, no. 7 (November 13, 1937), repro. p. 8; *Portfolio of French Painting, The Pennsylvania Museum Bulletin,* vol. 32, no. 176 (January 1938), repro.; "Recent Outstanding Acquisitions of American Museums," *The Art Quarterly,* vol. 1, no. 2 (Spring 1938), repro. p. 146; "Cézanne in America," *Art News Annual* (1938), repro. opp. p. 135; *Sixty-Second Annual Report of the Philadelphia Museum of Art...*(1938), repro. opp. p. 24; Barnes, 1939, repro. p. 284; Reginald Howard Wilenski, *Modern French Painters* (New York, 1939), pl. 49; *New Painting Galleries, The Philadelphia Museum Bulletin,* vol. 36, no. 187 (November 1940), repro.; *Handbook of the Museum, The Philadelphia Museum Bulletin,* vol. 37, no. 193 (March 1942), repro. p. 61; Malcolm Vaughan, "An Author's Eye for Painting," *The Art News,* vol. 42, no. 12 (November 1–14, 1943), repro. p. 15; Paul M. Laporte, "Cézanne and Whitman," *Magazine of Art,* vol. 37, no. 6 (October 1944), repro. p. 225; Wassily Kandinsky, *On the Spiritual in Art* (Boston, 1946), repro. p. 103; *The Task of the Museum, The Philadelphia Museum Bulletin,* no. 216 (January 1948), repro. p. 29; Dorival, 1948, pl. 160; Gotthard Jedlicka, *Cézanne* (Bern, 1948), fig. 50; *Masters in Art: Cézanne* (New York, 1948), repro. p. 6; Fritz Novotny, *Cézanne* (New York, 1948), pl. 87; Rewald, 1948, fig. 111; Schapiro, 1952, repro. p. 117; Rousseau, 1953, pl. 25; *Cézanne* (Geneva, 1954), p. 115; Klaus Berger, "Poussin's Style and the XIX Century," *Gazette des Beaux-Arts,* 97th year, 6th ser., vol. 45 (March 1955), p. 163, fig. 2; Fritz Saxl, *A Heritage of Images: A Selection of Lectures by Fritz Saxl,* ed. Hugh Honour and John Fleming (London, 1957), fig. 144; John Canaday, *Mainstreams of Modern Art* (New York, 1959), p. 357, fig. 433; Alfred Frankfurter, "Midas on Parnassus," *Art News*

Annual, vol. 28 (1959), repro. p. 39; Alfred Neumeyer, *Paul Cézanne: Die Badenden* (Stuttgart, 1959), fig. 8; Werner Hofmann, *The Earthly Paradise: Art in the Nineteenth Century* (New York, 1961), pl. 118; Melvin Waldfogel, "A Problem in Cézanne's *Grandes Baigneuses,*" *The Burlington Magazine,* vol. 104, no. 710 (May 1962), p. 202, fig. 33; "London Captures a Great Cézanne," *Art News,* vol. 63, no. 9 (January 1965), repro. p. 48; "Painting, A Cold Plunge," *Time,* February 12, 1965, p. 68; Philadelphia, PMA, *Check List of Paintings in the Philadelphia Museum of Art* (Philadelphia, 1965), p. 12; Henry Moore, *Henry Moore on Sculpture,* ed. Philip James (London, 1966), p. 192, pl. 72; Riccardo Barletta et al., *L'Arte moderna,* vol. 1, *Realtà e forma nel postimpressionismo* (Milan, 1967), repro. p. 145; George Heard Hamilton, *Painting and Sculpture in Europe, 1880 to 1940* (Baltimore, 1967), pl. 9A; C. Warren Hollister, ed., *Landmarks of the Western Heritage,* vol. 2, *1715 to the Present* (New York, 1967), repro. p. 313 (reversed); Ellen H. Johnson, *Paul Cézanne* (Paulton near Bristol, Eng.), 1967), pls. 10–11; Alberto Martini and Renata Negri, *Cézanne e il post-impressionismo* (Milan, 1967), p. 38, pl. 12; Ikegami, 1969, pl. 63; *Cézanne and the Post-Impressionists* (Milan, 1970), p. 30, pl. 12; Peter H. Feist, *Paul Cézanne* (Dresden, 1970), pl. 14; Miura, 1972, pl. 14; Fritz Erpel, *Paul Cézanne* (East Berlin, 1973), no. 28; Brion, 1974, repro. pp. 62–63; Yusuke Nakahara, *Cézanne* (Tokyo, 1974), pl. 27; *Cézanne,* The World Fine Arts, vol. 13 (Tokyo, 1975), pl. 4; Sidney Geist, "The Secret Life of Paul Cézanne," *Art International,* vol. 19, no. 9 (November 20, 1975), repro. p. 7; Orienti, 1975, pl. 55, p. 116, no. 657; Nicholas Wadley, *Cézanne and His Art* (London, 1975), pl. 65; Yasuo Kamon and Kawakita Michiaki, eds., *Cézanne* (Tokyo, 1976), pl. 21; Theodore Reff, "Cézanne's Late Bather Paintings," *Arts Magazine,* vol. 52, no. 2 (October 1977), p. 116, fig. 3; New York, 1977, p. 371, pl. 189; Georges A. Embirico, "Cézanne et la répétition," *Connaissance des Arts,* no. 315 (May 1978), repro. p. 73; Violette de Mazia, "Transferred Values: Part I—Introduction," *The Barnes Foundation Journal of the Art Department,* vol. 9, no. 2 (Autumn 1978), pl. 103; Paris, 1978, repro. p. 219; Venturi, 1978, repro. p. 126; Wim De Poorter et al., *Impressionisme en Symbolisme* (Brugge, 1979), fig. 7; *Art International* (May 1980), p. 13; Mary Louise Krumrine, "Cézanne's Bathers: Form and Content," *Arts Magazine,* vol. 54, no. 9 (May 1980), p. 116, fig. 3; Eldon N. Van Liere, "Solutions and Dissolutions: The Bather in Nineteenth-Century French Painting," *Arts Magazine,* vol. 54, no. 9 (May 1980), p. 113, fig. 27; Kalamazoo, Mich., Kalamazoo Institute of Arts, *Paris and the American Avant-Garde, 1900–1925* (June 12–July 21, 1980), p. 11, fig. 3; *Cézanne,* 25 Great Masters of Modern Art, vol. 10 (Tokyo, 1980), pl. 58; Norbert Lynton, *The Story of Modern Art* (Ithaca, N.Y., 1980), p. 19, pl. 7; Kimio Nakayama and Shuji Takashina, eds., *Nu féminin dans l'art* (Tokyo, 1980), vol. 10, Otsuro Sakazaki, *Temps moderne* (Tokyo, 1980), pl. 24; Peter Selz, *Art in Our Times: A Pictorial History 1890–1980* (New York, 1981), p. 100, pl. 227; Jean Arrouye, *La Provence de Cézanne* (Aix-en-Provence, 1982), pp. 98–99

DRAWINGS & WATERCOLORS

CÉZANNE WAS ONE of the great masters of watercolor; he used it throughout his life with great variety and range. Watercolor played an independent role within his *oeuvre,* for the most part not serving as a preparatory investigation of subjects eventually to be taken up in oil painting, but rather paralleling these subjects (*see* nos. 28, 36ʀ) and allowing him yet another means of recording his thoughts and considerations before the motif. From our perspective today, it seems at times that he used watercolor to create planes of color and tonal organizations that are almost abstract in intention (*see* nos. 29, 31), yet upon close examination they are always founded on the objects before him. Occasionally, shown here most dramatically in the great *Balcony* (no. 33), subjects appear in watercolor that do not occur in the paintings, as if the immediate brilliance of the color and the demanding technique (no reversals or rethinkings are possible in the quick-drying medium) led him to quite different areas of expressive possibilities.

Watercolor is intrinsically a frail medium, and changes have often occurred in the works which impede the viewer. Looking at Cézanne watercolors often requires considerable patience and forbearance, yet the visual pleasures abound even in the most impaired works.

Several types of distortions recur. Sheets worked on both sides, a regular practice for the artist in his sketchbooks (*see* nos. 23, 27) but also quite frequent even with single leaves, often have a "ghost," an image that has bled through from the reverse. More disturbing are the boundary lines around the edge of the paper, often a harsh brown, caused by the acid of the old mounts, which burned the paper. Most complex—and least understood—is the fading of the paper, which is particularly troublesome with Cézanne, who brought the exposed paper tone into the chromatic structure of his compositions. While it has often been assumed that the tones of the pigments themselves have shifted through exposure to light, and their original brilliance has dimmed, in nearly all of the watercolors discussed here, the primary alteration has been the discoloration of the paper itself. The total impression of the work has changed not because of a change in colors but because the degree of contrast has shifted throughout the entire sheet. Four sheets here (nos. 32–35) bear the mark of the same manufacturer and originally must have had the same tone of white. Now, however, the papers are greatly varied: *Oranges on a Plate* has darkened to a yellowed brown, for example, while *House on the Hill near Aix* has retained almost all of its original freshness. Many of the more subtle washes that were applied to *Oranges on a Plate* can no longer be distinguished on first view, the darkened tone of the paper having become closely merged with the values of the more thinly applied colors. However, once this is understood, the eye can adjust to the true variety of tones and begin a fuller reading of the range of colors.

23. Page from a sketchbook

RECTO: *HORSE'S HEAD; PORTRAIT OF HORTENSE FIQUET(?), 1872–74*

GRAPHITE ON PAPER
6⅝ x 10⅝″ (16.8 x 27 CM.)

VERSO: *TWO SEATED WOMEN; HEAD OF HORTENSE FIQUET, 1872–74*

GRAPHITE ON PAPER
6⅝ x 10⅝″ (16.8 x 27 CM.)
COLLECTION OF SYDNEY ROTHBERG, PHILADELPHIA

CÉZANNE'S SKETCHBOOKS are among the most evocative and touching works of their kind to come down to us. They are full of copy notes, compositional studies, casual observations of objects or figures, as well as lists and notations on all sorts of matters.[1] Here, on one page worked on both sides, several elements are represented: the lively horse's head (perhaps a chess piece, as suggested by Chappuis,[2] or more likely, a study after a series of Leonardo drawings, which he also copied elsewhere); the quickly noted head, probably of Hortense Fiquet, asleep in a chair; two peasant women, back to back; and a second, light sketch of his mistress. Over the drawing on the recto is written a draft of a letter, which is particularly revealing of the artist's situation with his parents:

> You ask me in your letter why I am not yet returning to Aix. Referring to this matter, I have already told you that it is more agreeable for me than you think to be with you, but that once at Aix I am no longer free there and when I want to return to Paris this always means a struggle for me; and although your opposition to my return is not absolute, I am very much troubled by the resistance I can feel on your part. I earnestly desire that my liberty of action should not be impeded and then I shall have all the more pleasure in hastening my return.
>
> I ask Papa to give me 200 frcs. a month, that will permit me to make a long stay at Aix, and I shall be very happy to work in the South where there is such a wide range of views for my painting. Believe me I do really beg Papa to grant me this request and then I shall, I think, be able to continue the studies I wish to make.
>
> Here are the last two receipts.[3]

As Rewald has noted, the urgent request for money from his family in the South—his father notoriously retaining a firm financial and emotional hold over the artist, who was already well into his thirties at this time—was probably to support his mistress and newly born son. The need to keep his son's birth a secret from his family kept Cézanne away from Aix between 1872 and 1875. While the existence of his child eventually became known to his parents through an intercepted letter, it was not until 1886, just before his father's death and the receipt of his inheritance, that he and Hortense were married and the child recognized, although he had always borne Cézanne's name and was one of the continuing joys of his life.

NOTES:
1. *See* Chappuis, 1973, vol. 1, pp. 20–23. *See also* Carl O. Schniewind, *Paul Cézanne, Sketchbook Owned by the Art Institute of Chicago,* 2 vols., facsim. ed. (New York, 1951).
2. Chappuis, 1973, vol. 1, p. 70, no. 88.
3. Cézanne, 1941, p. 95.

PROVENANCE: Ambroise Vollard, Paris; Pierre Loeb, Paris; Sotheby Parke Bernet, New York, sold June 15, 1979, lot 3, ill.; Sydney Rothberg, Philadelphia

EXHIBITIONS: None

BIBLIOGRAPHY: Vollard, 1914, pp. 33–34; Venturi, 1936, vol. 1, p. 352; Cézanne, 1941, p. 95, note; Chappuis, 1973, vol. 1, p. 70, no. 88, vol. 2, no. 88

24. OLYMPIA, c. 1877

GRAPHITE AND WATERCOLOR ON OFF-WHITE LAID PAPER

WATERMARK: VIDALON

9¾ x 11¼" (24.8 x 28.6 CM.)

PHILADELPHIA MUSEUM OF ART. THE LOUIS E. STERN COLLECTION

63-181-123

Edouard Manet (1832–1883)
Olympia, 1863
Oil on canvas, 51 x 75"
Musée du Louvre, Paris

THE EXPOSITION OF Manet's reclining nude *Olympia* in 1863 caused a sensation in Paris and reinforced the artist's role as the rallying figure for progressive painters. This group, who gathered at the Café Guerbois, sometimes included the young Cézanne, although his natural wariness of the elegant Parisians and, undoubtedly, a deep shyness at his own provincial manners and independence of thought kept him at a distance from the others in the group. In the 1870s Cézanne painted two small works showing a maid presenting a nude, opulent courtesan to a fully dressed man (Venturi 106, 225), which have been taken as rather light-hearted parodies of the *Olympia*. To these can be added three watercolors: this, and two others (Venturi 884, 886), which are closer studies of the courtesan and her maid, two of them including a charming cat, a prominent element also in the *Olympia* itself. However, Cézanne's subject could just as well relate to Manet's equally notorious *Déjeuner sur l'Herbe* (when the present title was given to this watercolor is unclear), where clothed men are shown with female nudes, or his own variant, much in the spirit of both pictures, of the *Eternel Féminin* (Venturi 247), in which the theme of desire and the battle of the sexes is brought to a brazen and raucous climax.

As Rewald observes, the handling of the watercolor here is essentially illustrative, following the fully worked-out pencil design and acting only as a supplement to it; in the other watercolors, it is allowed much more independence, giving a greater vigor to the execution. In the context of this presentation, this work must be compared to the copy after Delacroix (no. 1), an example of Cézanne's impassioned and dramatic subjects and almost violent handling of paint during the late 1860s and early 1870s. Here, however, there is a sense of deliberation and even levity (rare for Cézanne at any point in his career), which suggest that even in a subject so erotic, much of the tension and anxiety of his earlier works, or earlier variants on this general theme, has lifted. Now the little encounter can be presented with all of its matter-of-fact humor—the visitor, for example, has forgotten to remove his hat—albeit with rather sinister, moralistic overtones.

PROVENANCE: the artist's son, Paris; Galerie Renou et Colle, Paris; Fine Arts Associates (Otto M. Gerson), New York; Louis E. Stern, New York, purchased 1950; Philadelphia Museum of Art, by bequest, 1963

EXHIBITIONS: Paris, Galerie Renou et Colle, *Aquarelles et baignades de Cézanne* (June 3–17, 1935); New York, Valentine Gallery (Dudensing), *Cézanne Watercolors* (1937), no. 17; New York, Fine Arts Associates (Otto M. Gerson), *Modern Painters—Old Masters* (1949); New York, Fine Arts Associates (Otto M. Gerson), *Cézanne, Rarely Shown Works* (November 10–29, 1952), watercolor no. 3; New York, 1959, no. 60; New York, The Brooklyn Museum, *The Louis E. Stern Collection* (September 25, 1962—March 10, 1963), p. 14, no. 109; New York, 1963, no. 3, pl. 2

BIBLIOGRAPHY: Rivière, 1923, repro. p. 149; Venturi, 1936, vol. 1, p. 248, no. 882, vol. 2, pl. 279, no. 882; Neumeyer, 1958, p. 37, pl. 8; John Canaday, *Mainstreams of Modern Art* (New York, 1959), p. 349, fig. 422; Ira Moskowitz, ed., *Great Drawings of All Time*, vol. 3, *French, Thirteenth Century to 1919* (New York, 1962), pl. 811; Philadelphia, PMA, *The Louis E. Stern Collection* (Philadelphia, 1964), p. 25, no. 18; Jack Lindsay, *Cézanne, His Life and Art* (London, 1969), fig. 81; Theodore Reff, *Manet: Olympia* (New York, 1976), p. 34, fig. 12; Götz Adriani, *Paul Cézanne: "Der Liebeskampf"—Aspekte zum Frühwerk Cézannes* (Munich, 1980), p. 54, fig. 5; Nello Ponente et al., *Cézanne e le avanguardie* (Rome, 1981), fig. 12; Rewald, 1983, no. 135

25. RECTO: *ROCKS AND TREES, 1880–85*
(Rochers et Arbres)

WATERCOLOR ON PAPER
WATERMARK: PL BAS
12¼ x 18⅞″ (31.1 x 47.9 CM.)

VERSO: *A FOREST OF STANDING TIMBER, 1880–85*
(La Futaie)

GRAPHITE AND WATERCOLOR ON PAPER
12¼ x 18⅞″ (31.1 x 47.9 CM.)
PHILADELPHIA MUSEUM OF ART
THE LOUISE AND WALTER ARENSBERG COLLECTION
50-134-AI-33

THE FRONT OF this sheet depicts a wall of tall and elegant trees bordering a sandy clearing. The frieze of thin washes across the surface, pierced by the slim, blue lines of the trunks, creates a shallow, tightly woven space of great loveliness. Cézanne subtly allowed certain colors to bleed from left to right to emphasize further the screenlike effect of his diaphanous wall, which with the most delicate of washes, is carried completely to the right of the page. It compares to those more ambitious painted landscapes of this period, *The View of Médan* (Venturi 325), for example, in which a series of receding planes—like scrims in the theater—create a space of great restraint and stability.

The reverse, in which the watercolor is primarily confined to the center of the page, continues the same formal symmetry; the central clump of trees, flanked by two screens of drawn foliage, maintains, despite the absence of color, the same plane as the brushed-in central area.

PROVENANCE: the artist's son, Paris; Bernheim-Jeune, Paris; Charles Vignier, Paris; Marius de Zayas, New York; Louise and Walter Arensberg, New York and Hollywood, Calif.; Philadelphia Museum of Art, 1950

EXHIBITIONS: Paris, Galerie Bernheim-Jeune, *Aquarelles et pastels* (1909), no. 18; New York, The Little Galleries of the Photo-Secession, "Exhibition of Twenty Watercolors by Cézanne" (March 1–25, 1911), no. 3; New York, Montross Gallery, *Cézanne* (1916), no. 10; Oakland, Calif., Mills College Art Gallery, *European Master Drawings of the Nineteenth and Twentieth Centuries* (February 19–March 29, 1939), no. 14; Chicago,

The Art Institute of Chicago, *20th Century Art. From the Louise and Walter Arensberg Collection* (October 20–December 18, 1949), p. 26, no. 37; New York, Solomon R. Guggenheim Museum, *Paintings from the Arensberg and Gallatin Collections of the Philadelphia Museum of Art* (1961)

BIBLIOGRAPHY: Willard Huntington Wright, "Paul Cézanne," *The International Studio*, vol. 52, no. 228 (February 1916), p. 130; Venturi, 1936, vol. 1, p. 263, no. 984, vol. 2, pl. 296, no. 984; Philadelphia, PMA, *The Louise and Walter Arensberg Collection: 20th Century Section* (Philadelphia, 1954), no. 32; Neumeyer, 1958, p. 60, pl. 83; Rewald, 1983, nos. 151, 233

RECTO

VERSO

56

26. Page from a sketchbook

RECTO: *CARAFE, TABLE KNIFE, AND UNIDENTIFIED OBJECT,* c. 1882
(Carafe et Couteau)

GRAPHITE AND WATERCOLOR ON PAPER
8⅝ x 10¾″ (21.9 x 27.3 CM.)

VERSO: *METAL BED WITH RUMPLED BEDCLOTHING AND TABLE,*
1885–87
(Lit et Table)

GRAPHITE AND WATERCOLOR ON PAPER
10¾ x 8⅝″ (27.3 x 21.9 CM.)
PHILADELPHIA MUSEUM OF ART. A.E. GALLATIN COLLECTION
52-61-11

THE ROUGHLY TORN left edge of this page, as well as the carefully inscribed Roman numeral LXVII on the lower right of the recto, suggests that it was once a part of a sketchbook, probably what Chappuis has referred to as Chappuis IV, a large album that was broken up at some point after it was sold by Paul Guillaume in 1933 (although, as Chappuis notes, several pages must already have been pulled from the album by this time, indicated by the provenance of this sheet).[1] Chappuis also illustrates a finished pencil drawing of the same bed, which is from the same sketchbook (Chappuis 959).

These two remarkably candid drawings demonstrate yet another use Cézanne made of watercolors, particularly within the context of his sketchbooks. They often record mundane objects, which he placed firmly on the page—experimenting here, in the still life of carafe and knife, with the manner in which color and the white of the paper could be brought to represent with great economy a remarkably convincing space; or, as on the verso, with a complex linear jumble, full of curves and folds.

The attributing of different dates to the sides is not unusual, since Cézanne often kept one, or several, sketchbooks over a period of years, adding drawings and watercolors in a rather haphazard order.

NOTE:
1. Chappuis, 1973, vol. 1, p. 22.

PROVENANCE: Georges Bernheim, Paris; Bernheim-Jeune, Paris; Montross Gallery, New York; A.E. Gallatin, New York; Philadelphia Museum of Art, by bequest, 1952

EXHIBITIONS: New York, Montross Gallery, *Cézanne* (1920); New York, Museum of French Art, The Institute of French Art in America, *Works by Cézanne, Redon, Degas, Rodin, Gauguin, Derain, and Others* (March 16–April 3, 1921), no. 15

BIBLIOGRAPHY: Eugenio d'Ors, *Paul Cézanne* (Paris, 1930), pl. 17; New York, New York University, Gallery of Living Art, *A.E. Gallatin Collection* (New York, 1933), no. 19; Eugenio d'Ors, *Paul Cézanne* (Paris, 1936), pl. 35; Venturi, 1936, vol. 1, p. 284, no. 1143, vol. 2, pl. 328, no. 1143; New York, New York University, Museum of Living Art, *A.E. Gallatin Collection* (New York, 1940), no. 23; Philadelphia, PMA, *A.E. Gallatin Collection: "Museum of Living Art"* (Philadelphia, 1954), p. 30, no. 27; Rewald, 1983, nos. 165, 202

27. Page from a sketchbook

RECTO: *THE BLUE CACHEPOT*, c. 1885
(*Le Cache-pot Bleu*)

GRAPHITE, WATERCOLOR, AND GOUACHE ON WHITE PAPER
8½ x 4¾″ (21.6 x 12.1 CM.)

VERSO: *THE ARTIST'S SON*, c. 1885

GRAPHITE ON WHITE PAPER
8½ x 4¾″ (21.6 x 12.1 CM.)
COLLECTION OF MARC SALZ, PHILADELPHIA

THIS PAGE FROM a sketchbook (Chappuis II) depicts a metal cachepot holding a plant with long, slim leaves. Some of the stalks have begun to turn brown and their rangy amplitude—one having already fallen over—suggests that the plant has already flowered and is being allowed to grow out. The pot sits on a shelf, perhaps a window-sill, covered by a brightly colored, tufted cloth. At the upper left, a brown plane (a shade or a curtain?) divides some of the leaves. In this compact and intense image, the densely applied lean pigments follow the pencil drawing with precise delineation and are dragged over the surface very dryly, maintaining a consistent opacity further emphasized by the white gouache highlights (slightly toned with blue) of the cachepot. The blue of the metal is as aggressive as the brilliant, emerald green of the plant; the undulating ribs of the pot stand in similar contrast to the sharp, pointed leaves. Chappuis illustrates a page from the same sketchbook (Chappuis 537) with a pencil drawing of the rippling side of the pot.

The pencil drawing of Cézanne's son Paul on the reverse is equally bold, showing the boy asleep, wearing a soft cap. As with nearly all Cézanne's portraits of his son, it is a deeply affecting work of great tenderness; it also shows how much the child, with his sharp chin and broad forehead, must have resembled his mother (*see* no. 12). The concise, diagonal strokes are drawn with a soft, blunt pencil. The profile outline of a hat (and of another just suggested) on the lower left, instinctively balance for Cézanne the boy's right cheek, which is left unrendered.

PROVENANCE: Ambroise Vollard, Paris; Auguste Pellerin, Paris; René Lecomte and Mme Lecomte (née Pellerin), Paris; Collection Mme X, Galerie Charpentier, sold Paris, June 8, 1956, no. 3; Sam Salz, New York; Marc Salz, Philadelphia

EXHIBITIONS: Paris, Orangerie des Tuileries, *Hommage à Cézanne* (July 2–October 17, 1954), p. 28, no. 68; New York, 1963, p. 25, no. 8, pl. 4

BIBLIOGRAPHY: Venturi, 1936, vol. I, p. 335, no. 1539A, vol. 2, pl. 391, no. 1539A; Wayne V. Andersen, *Cézanne's Portrait Drawings* (Cambridge, Mass., 1970), no. 125; Rewald, 1983, no. 229

RECTO VERSO

59

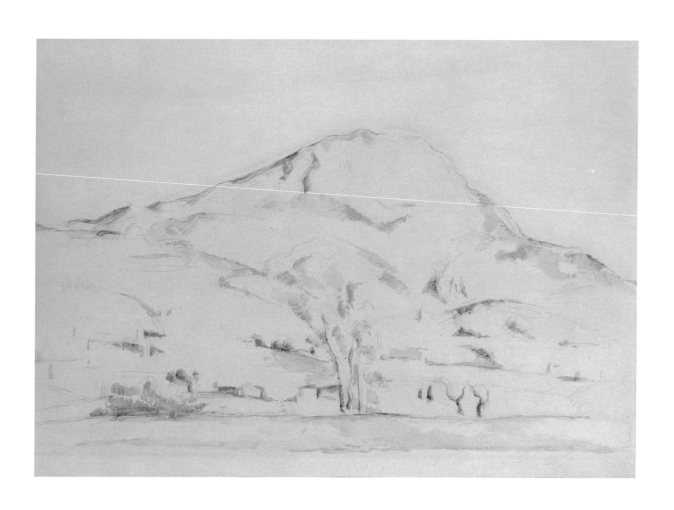

28. *MONT SAINTE-VICTOIRE, 1885–87*
(*La Montagne Sainte-Victoire*)

GRAPHITE AND WATERCOLOR ON WHITE PAPER
15¼ x 19⅝″ (38.7 x 49.8 CM.)
COLLECTION OF HENRY P. McILHENNY, PHILADELPHIA (GIFT TO THE FOGG ART MUSEUM,
HARVARD UNIVERSITY, CAMBRIDGE, MASS.; RESERVING LIFE INTEREST)

THIS VIEW of the mountain is less dramatic than other representations of Cézanne's most powerful motif. The breaking crest of its peak, which can become an almost lunging form in certain views (no. 20, for example), is shown from an angle that is more blunt and subdued. In addition, the slope extends well into the middle ground in this rather close-on representation of the mountain, allowing a more gradual ascent through space. The watercolor is placed very discretely over the surface, and the white of the paper participates in the spatial definition in a truly remarkable way. But, in its markedly restrained and unhurried presentation, the looming bulk of the mountain is evoked all the more effectively.

PROVENANCE: Roulard, Bernheim-Jeune, Paris; Vicomte Bernard d'Hendecourt, Paris; Sotheby's, London, sold May 9, 1929, no. 165, ill.; Paul Rosenberg, Paris and New York; Paul J. Sachs, Cambridge, Mass.; Jacques Seligmann, New York; Henry P. McIlhenny, Philadelphia; Fogg Art Museum, Harvard University, Cambridge, Mass., gift of Henry P. McIlhenny (reserving life interest)

EXHIBITIONS: London, Burlington Fine Arts Club, *Catalogue of Pictures, Drawings, and Sculpture of the French School of the Last 100 Years* (1922), p. 20, no. 67; New York, Museum of Modern Art, *Cézanne, Gauguin, Seurat, Van Gogh* (1929), no. 30; New York, Jacques Seligmann & Co., Inc., *Watercolors by Cézanne* (November 16–December 7, 1933), no. 16; Northampton, Mass., Smith College Museum of Art, *Watercolors* (1933), no. 19; Cambridge, Mass., Harvard University, Fogg Art Museum, *Nineteenth Century French Prints and Drawings* (March 15–April 30, 1934), no. 42; Philadelphia, 1934, no. 56; Buffalo, The Buffalo Fine Arts Academy, Albright Art Gallery, *Master Drawings, Selected from the Museums and Private Collections of America* (January 1935), no. 125; San Francisco, San Francisco Museum of Art, *Paul Cézanne: Exhibition of Paintings, Water-Colors, Drawings and Prints* (September 1–October 4, 1937), no. 44; New York, 1939, no. 23; Boston, Museum of Fine Arts, *A Thousand Years of Landscape East and West (Paintings, Drawings, Prints)* (October 24–December 9, 1945), p. 3; Philadelphia, PMA, *Masterpieces of Philadelphia Private Collections* (May 1947), p. 79, no. 160; Philadelphia, PMA, "The Henry P. McIlhenny Collection" (1949); Cambridge, Mass., Harvard University, Fogg Art Museum, "Class of 1933 Exhibition" (1958); San Francisco, The California Palace of the Legion of Honor, *The Henry P. McIlhenny Collection: Paintings, Drawings and Sculpture* (June 15–July 31, 1962), no. 3; Washington, D.C., The Phillips Collection, *Cézanne: An Exhibition in Honor of the Fiftieth Anniversary of the Phillips Collection* (February 27–March 28, 1971), no. 43; Allentown, Pa., Allentown Art Museum, *French Masterpieces of the 19th Century from the Henry P. McIlhenny Collection* (May 1–September 18, 1977), repro. p. 75

BIBLIOGRAPHY: Roger Fry, "French Art of the Nineteenth Century—Paris," *The Burlington Magazine*, vol. 40, no. 231 (June 1922), repro. p. 267; Venturi, 1936, vol. 1, pp. 337–38, no. 1561, vol. 2, pl. 395, no. 1561; David M. Robb, *The Harper History of Painting: The Occidental Tradition* (New York, 1951), p. 774, fig. 424; Rosamond Bernier, "Le Musée privé d'un conservateur," *L'Oeil*, no. 27 (March 1957), repro. p. 24; John Canaday, *Mainstreams of Modern Art* (New York, 1959), p. 356, fig. 432; Rewald, 1983, no. 200

29. RECTO: *TREES AND ROCKS*, c. 1890
(*Arbres et Rochers*)

GRAPHITE AND WATERCOLOR ON PAPER
17¾ x 11½″ (45.1 x 29.2 CM.)

VERSO: *VIEW OF THE PILON DU ROI*, c. 1890

29a. Paul Cézanne
Le Pilon du Roi
Oil on canvas, 31 x 39″
Sammlung Dr. Oskar Reinhart, Winterthur,
Switzerland

29b. Paul Cézanne
Le Pilon du Roi
Oil on canvas, 19 x 23″
Glasgow Museum and Art Galleries

29c. Paul Cézanne
Le Pilon du Roi
Oil on canvas, 23¾ x 31¾″
© Barnes Foundation, Merion, Pa.

GRAPHITE ON PAPER
11½ x 17¾″ (29.2 x 45.1 CM.)
PHILADELPHIA MUSEUM OF ART
THE SAMUEL S. WHITE, 3RD, AND VERA WHITE COLLECTION
67-30-19

SINCE ITS RECENT RESTORATION, the striking complexity and spatial nuances of this watercolor can be appreciated anew, although the paper remains badly discolored. Cézanne's depiction of trees growing out of a rocky ravine is executed, both in its pencil drawing and watercolor technique, with considerable energy and virility. The blunt, pencil rendering of the boulders in the foreground is paralleled by the bold and free application of washes on the trees and foliage above, while the ultramarine blue outline of the two saplings to the left ascends with a flamelike exuberance.

Given this image of rocks and trees, the drawing on the reverse has often been seen as two tree trunks. However, when properly read in a horizontal direction, it clearly becomes a panoramic landscape: closed on the left by trees and with a clump of foliage in the center, the view leads over a gentle knoll in the middle ground to the massive range of mountains beyond. The two prominent stumplike projections of rocks on its profile to the right, in fact, can be identified as the eastern extension of the chaine de l'Etoile, a range of mountains south of Aix, and more specifically, the so-called Pilon du Roi (from the pestle-like projections), which Cézanne painted at least three times (figs. 29a, b, c; respectively, Venturi 658, 418, 301) and which are clearly visible in the photograph looking south from the studio at Les Lauves (*see* fig. 35a). Landscape drawings of this panoramic clarity, particularly those without the addition of watercolor, are rare in Cézanne's work, and it is tempting to speculate that he was considering a painting of this particular motif, although none of the painted views align closely enough to confirm this.

PROVENANCE: the artist's son, Paris; Bernheim-Jeune, Paris; Montross Gallery, New York; Mr. and Mrs. Samuel S. White, 3rd, Ardmore, Pa., purchased 1924; Philadelphia Museum of Art, by bequest, 1967

EXHIBITIONS: New York, The Little Galleries of the Photo-Secession, "Exhibition of Twenty Watercolors by Cézanne" (March 1–25, 1911), no. 16; New York, Montross Gallery, *Cézanne* (1916), no. 14; Philadelphia, Pennsylvania Museum of Art, "The White Collection" (December 9, 1933–January 10, 1934); Philadelphia, 1934, no. 53; New York, 1939, no. 27; Columbus, Ohio, Columbus

Gallery of Fine Arts, *Cézanne Watercolors* (1939–40), no. 5 or 6; New York, 1947, p. 70, no. 76; Philadelphia, PMA, "S.S. White, 3rd Collection" (1950); Philadelphia, PMA, "The Samuel S. White, 3rd, and Vera White Collection" (1962–66)

BIBLIOGRAPHY: Venturi, 1936, vol. 1, p. 256, no. 933, vol. 2, pl. 287, no. 933; *The Samuel S. White, 3rd, and Vera White Collection, Philadelphia Museum of Art Bulletin*, vol. 63, nos. 296–97 (January–March and April–June 1968), p. 106, no. 52; Rewald, 1983, no. 328

RECTO

VERSO

63

30. *GIRL WEARING A FICHU*, 1890–93
(*Jeune Paysanne*)

GRAPHITE ON WHITE PAPER
WATERMARK: MICHALLET
6⅛ x 8⅝″ (15.6 x 21.9 CM.)
COLLECTION OF HENRY P. McILHENNY, PHILADELPHIA

IN DISCUSSING Cézanne's drawings, Kenneth Clark speaks of the "mysterious conspiracy with the white paper";[1] and this beautiful head of a girl illustrates his observation well. With the greatest economy of means, the artist not only created a head and shoulders of resounding three dimensionality but also through the lightly hatched band on the right, suggested an atmospheric sense with a full spatial context. There is a firm, yet gentle decisiveness to the drawing, the expanse of the right cheek given over entirely to the white of the paper. In handling and mood it compares most closely here to the portrait of Madame Cézanne (no. 15). Chappuis places the work very early in Cézanne's career, relating it to the young woman portrayed in the 1873 etching done at Auvers (no. 38).[2] Theodore Reff[3] and Clark argue persuasively for a considerably later date.

The presence of this still and haunting figure within Cézanne's *oeuvre* is particularly striking since his portrait subjects, in both drawing and painting, are nearly always close friends or members of his household, who could be persuaded into sitting with some frequency. This is the only instance in which this lovely yet melancholy face appears in Cézanne's work.

NOTES:
1. Kenneth Clark, "The Enigma of Cézanne," *Apollo*, n.s., vol. 99, no. 149 (July 1974), p. 80.
2. Chappuis, 1973, vol. 1, p. 108, no. 273.
3. Theodore Reff, "Cézanne Drawings," *The Burlington Magazine*, vol. 117, no. 868 (July 1965), p. 490.

PROVENANCE: Dr. Gachet, Auvers-sur-Oise; A. Daber, Paris; Henry P. McIlhenny, Philadelphia

EXHIBITIONS: Paris, 1936, pp. 141–42, no. 145; Allentown, Pa., Allentown Art Museum, *French Masterpieces of the 19th Century from the Henry P. McIlhenny Collection* (May 1–September 18, 1977), repro. p. 77

BIBLIOGRAPHY: Rewald, 1936, p. 81; Venturi, 1936, vol. 1, p. 347; Theodore Reff, "Cézanne Drawings," *The Burlington Magazine*, vol. 117, no. 868 (July 1965), p. 490; Chappuis, 1973, vol. 1, p. 108, no. 273, vol. 2, no. 273; Kenneth Clark, "The Enigma of Cézanne," *Apollo*, n.s., vol. 99, no. 149 (July 1974), pp. 79–80

31. TREES AND ROCKS, c. 1895
(Arbres et Rochers)

WATERCOLOR AND GRAPHITE ON OFF-WHITE LAID PAPER
18¾ x 12½″ (47.6 x 31.8 CM.)
PHILADELPHIA MUSEUM OF ART
THE SAMUEL S. WHITE, 3RD, AND VERA WHITE COLLECTION
67-30-18

GIVEN THEIR similarity in subject—trees growing from a rock-strewn shelf—and the fact that they entered the Museum from the same collection, where they had both been since the 1920s, this watercolor and number 29 have been either confused or treated as pendants. Yet they are strikingly different, and they underscore Cézanne's ability to handle two very similar motifs in very different manners. In the earlier watercolor, the graphite drawing and the watercolor work in two quite separate but mutually reinforcing areas: the graphite essentially restricted to the foreground, while the color (little guided by previously drawn lines) emerges in the upper areas. Here, the two mediums constantly interplay in the definition of forms and space. The large rock on the left, for example, was first drawn in a series of quick pencil marks and then further outlined by similarly broken strokes of the brush. The same method was applied to the definition of the trees and the tumble of boulders beyond. This work is, by comparison, much lower keyed, the pencil and the watercolor more integrated, creating a gentler, more subtly balanced definition of space.

The broad passages of khaki-green wash are a distortion of the original color: a close examination of the few particles that have not shifted down in tonality show that they were emerald green, and must have initially appeared much more brilliant. Likewise, the yellowing of the paper has somewhat subdued the animated clarity of the pencil drawing.

PROVENANCE: Walther Halvorsen, Oslo; Bernheim-Jeune, Paris; Mr. and Mrs. Samuel S. White, 3rd, Ardmore, Pa.; Philadelphia Museum of Art, by bequest, 1967

EXHIBITIONS: Philadelphia, Pennsylvania Museum of Art, "The White Collection" (December 9, 1933–January 10, 1934); Philadelphia, 1934, no. 54; New York, 1939, no. 27; Columbus, Ohio, Columbus Gallery of Fine Arts, *Cézanne Watercolors* (1939–40), no. 5 or 6; New York, 1947, p. 70, no. 75; Philadelphia, PMA, "S.S. White, 3rd Collection" (1950); Philadelphia, PMA, "The Samuel S. White, 3rd, and Vera White Collection" (1962–66)

BIBLIOGRAPHY: Venturi, 1936, vol. 1, p. 256, no. 930, vol. 2, pl. 287, no. 930; *The Samuel S. White, 3rd, and Vera White Collection, Philadelphia Museum of Art Bulletin*, vol. 63, nos. 296–97 (January–March and April–June 1968), p. 104, no. 51; Rewald, 1983, no. 418

32. HOUSE ON THE HILL NEAR AIX, 1895–1900
(Maison sur une Colline aux Environs d'Aix)

GRAPHITE AND WATERCOLOR ON WHITE WOVE PAPER
WATERMARK: MONTGOLFIER/SAINT/MARCEL/LES/ANNONAY
18¾ x 22½" (47.6 x 57.1 CM.)
PHILADELPHIA MUSEUM OF ART. THE LOUIS E. STERN COLLECTION
63-181-7

THIS BROAD VIEW over trees to the opposite hill is similar to several of the prospects near the chemin des Lauves north of Aix, where Cézanne would eventually build his studio (*see* Venturi 1037). Rewald points out, however, that there are many such isolated buildings on elevated spots in Provence and it would be ill advised to attempt to locate them too specifically from so generalized a depiction as this one.

This is a particularly dramatic and sweeping landscape; the pile of washes and tangle of trees are restricted to the foreground, while the winding path leads to the much more summarily handled hill in the distance. Of all the watercolors shown here, this is certainly the best preserved, the paper retaining much of its original whiteness so that the freshness and subtlety of the washes can be seen much as they must have been when the work was created.

PROVENANCE: the artist's son, Paris; Bernheim-Jeune, Paris; Montross Gallery, New York; John Quinn, New York; Mrs. Cornelius J. Sullivan, New York; Anderson Galleries, New York, Sullivan Estate Collection, sold American Art Association, April 29–May 1, 1937, no. 78, ill.; E & A Silberman Galleries, New York; Louis E. Stern, New York; Philadelphia Museum of Art, by bequest, 1963

EXHIBITIONS: Paris, Galerie Bernheim-Jeune, *Aquarelles et pastels* (1909), no. 16; London, Grafton Galleries, *Second Post-Impressionist Exhibition* (1912), no. 169; Brussels, Salon de la Libre Esthétique, *Interprétations du Midi* (1913), no. 52; New York, Montross Gallery, *Cézanne* (1916), no. 9; New York, Fine Arts Associates (Otto M. Gerson), *Cézanne, Rarely Shown Works* (November 10–29, 1952), watercolor no. 7; New York, 1959, no. 75; New York, The Brooklyn Museum, *The Louis E. Stern Collection* (September 25, 1962–March 10, 1963), p. 4, no. 8

BIBLIOGRAPHY: *John Quinn, 1870–1925: Collection of Paintings, Water Colors, Drawings & Sculpture* (New York, 1926), repro. p. 36; Venturi, 1936, vol. 1, p. 261, no. 976, vol. 2, pl. 295, no. 976; Philadelphia, PMA, *The Louis E. Stern Collection* (Philadelphia, 1964), p. 26, no. 20; Rewald, 1983, no. 464

RECTO

VERSO

70

33. RECTO: *THE BALCONY,* c. 1900 or later
(Le Balcon)

GRAPHITE AND WATERCOLOR ON WHITE PAPER
WATERMARK: CANSON & MONTGOLFIER/VIDALON
24 x 17¾″ (61 x 45.1 CM.)

VERSO: *FOLIAGE,* 1895–1900
(Etude de Verdure)

GRAPHITE AND WATERCOLOR ON WHITE PAPER
17¾ x 24″ (45.1 x 61 CM.)
PHILADELPHIA MUSEUM OF ART. A.E. GALLATIN COLLECTION
43-75-1

33a. Detail of the facade of the Hôtel d'Albertas, Aix-en-Provence

EVEN AMONG the brilliancy of Cézanne's later watercolors, the scale and energy of this sheet stand out as astonishing. The spiral curves of the wrought-iron grille are given the dynamism of a Saint Catherine's wheel: rapid strokes of intense blue and gray-black alternate in great pulsating curves, while the rich strokes of color of the trees in full leaf beyond dazzle in their freshness as they catch the light. The drawing, itself very loose and spontaneous, has a life of its own, not dictating the placement of the color but rather paralleling it in exuberant animation. An altogether striking image, it is, as Theodore Reff notes, more spiritually akin to "van Gogh's ecstatic vision of a starry sky than to the decorative or formally contrived balconies of Matisse,"[1] which, on one level, seem to draw so much from this famous work.

The "balcony" itself has been the subject of frequent discussion. It seems likely that it is not, in fact, a balcony of a French window, but rather a long window with a partially open exterior shutter on the left, a type of shutter that divides, allowing the bottom third to be open completely. This kind of window arrangement seems to have been typical of the grander houses in Aix, as illustrated by a view of the windows of the Hôtel d'Albertas there, which have much the same arrangement (*see* fig. 33a).

The sketch on the reverse has usually been described simply as foliage and, when compared to a watercolor in the Museum of Modern Art (Venturi 1128), does seem to be an initial, but by no means tentative, rendering, rather close up, of a stalky bush or group of plants. In its broad sweep of washes and animated drawing it shares, in a less fully realized manner, much of the spontaneity and joyous spirit of the more finished image on the recto.

NOTE:
1. Theodore Reff, "Cézanne: The Logical Mystery," *Art News,* vol. 62, no. 2 (April 1963), p. 28.

PROVENANCE: the artist's son, Paris; Bernheim-Jeune, Paris; Museum of Living Art, New York University (A.E. Gallatin Collection); Philadelphia Museum of Art, by bequest, 1943

EXHIBITIONS: Paris, Galerie Bernheim-Jeune, *Aquarelles et pastels* (1909), no. 13; Chicago, 1952, p. 97, no. 124; New York, 1963, p. 51, no. 53, pl. 49; Washington, D.C., The Phillips Collection, *Cézanne: An Exhibition in Honor of the Fiftieth Anniversary of the Phillips Collection* (February 27–March 28, 1971), no. 53; Newcastle upon Tyne, Laing Art Gallery, *Watercolour and Pencil Drawings by Cézanne* (September 19–November 4, 1973), no. 91; New York, 1977, p. 360, pl. 175, p. 411, cat. no. 94; Paris, 1978, p. 116, no. 28

BIBLIOGRAPHY: New York, New York University, Gallery of Living Art, *Catalogue* (New York, 1929), n.p.; New York, New York University, Gallery of Living Art, *A.E. Gallatin Collection* (New York, 1933), no. 18; Venturi, 1936, vol. 1, p. 281, no. 1126, vol. 2, pl. 324, no. 1126; New York, New York University, Museum of Living Art, *A.E. Gallatin Collection* (New York, 1940), no. 24; Philadelphia, PMA, *A.E. Gallatin Collection: "Museum of Living Art"* (Philadelphia, 1954), p. 11, no. 28; Neumeyer, 1958, p. 60, no. 85; Theodore Reff, "Cézanne: The Logical Mystery," *Art News,* vol. 62, no. 2 (April 1963), p. 28, fig. 1; Fritz Erpel, *Paul Cézanne* (East Berlin, 1973), repro.; Rewald, 1983, no. 529

34. ORANGES ON A PLATE, c. 1900
(Oranges sur une Assiette)

WATERCOLOR ON WHITE PAPER

WATERMARK: ANC^{NE} MANUF^{RE}/CANSON & MONTGOLFIER/VIDALON-LES-ANNONAY

12⅜ x 18¾″ (31.4 x 47.6 CM.)

PHILADELPHIA MUSEUM OF ART. MR. AND MRS. CARROLL S. TYSON, JR. COLLECTION

63-116-20

34a. Ultraviolet photograph of
Oranges on a Plate
PMA. Conservation Department

THIS COMPOSITION would appear to be completely straightforward, if not somewhat static: five oranges are carefully and evenly arranged in a spiral pattern on a white plate, while another is just to the right; all are seen against a background of vertical stripes. Seemingly simple and uncomplicated at first, on close examination it is clearly one of the most technically complex and deliberate watercolors by Cézanne.

The plate and fruit are lightly suggested in pencil, which is used as much to place them spatially on the table as to establish their outlines. To this is applied a series of watercolor strokes of red (probably carmine), orange, yellow, and blue, which range from an almost gouachelike density to the thinnest of washes. The role of the blue, which in factual terms would have been confined to the border of the plate, is truly remarkable: it becomes, at the same time, the oval of the plate, its deep shadow, the receding sides of the oranges, and their shadows as well. The reds and yellows build over the rounded fruits in a series of planes, sometimes carefully contained, at other times allowed to overlap and to glaze one another to reinforce their complementary brilliance.

The same colors are used in the wallpaper background, but are applied in more even washes, which build up and glaze over one another to create a constant yet pulsating field of complex color. For this effect, the palette extends here to a variety of greens and purples and to several earth tones.

The paper has, through light damage, yellowed considerably from its original white, appearing now as a slightly pink, buff color. Therefore the viewer must be particularly observant to see the full complexity of this work; however, through ultraviolet photography (fig. 34a), which stresses the nuances of the washes, a better sense of the original state of this watercolor can be revealed.

PROVENANCE: the artist's son, Paris; Etienne Bignou, Paris; Georges F. Keller, Paris; Galerie Charpentier, Paris, sold June 26, 1934, no. 1; Reid & Lefèvre, London; G. Maculloch Miller, London; Whitney Straight, London; Wildenstein Galleries, New York; Carroll S. Tyson, Jr., Philadelphia; Estate of Helen R. Tyson, Philadelphia; Philadelphia Museum of Art, by bequest, 1963

EXHIBITIONS: Ottawa, The National Gallery, *Exhibition of French Painting of the Nineteenth Century* (January 1934), p. 12, no. 17; Glasgow, The McLellan Galleries, *French Painting in the Nineteenth Century* (May 1934), no. 5; London, Lefèvre Gallery, *Paintings by Cézanne (1839–1906)* (1935), no. 13; Philadelphia, PMA, *Masterpieces of Philadelphia Private Collections* (May 1947), p. 79, no. 146; New York, 1947, p. 72, no. 80

BIBLIOGRAPHY: Rivière, 1923, p. 221; Venturi, 1936, vol. 1, p. 282, no. 1133, vol. 2, pl. 326, no. 1133; John Rewald, "The Collection of Carroll S. Tyson, Jr., Philadelphia, U.S.A.," *The Connoisseur,* vol. 134 (August 1954), repro. p. 66 (reprinted in *Philadelphia Museum of Art Bulletin,* vol. 59, no. 280 [Winter 1964], repro. p. 75); Neumeyer, 1958, p. 53, no. 61; *Génies et Réalités* (Paris, 1966), fig. 144; Brion, 1974, repro. p. 80; New York, 1977, p. 363, pl. 179 [incorrect caption]; Rewald, 1983, no. 553

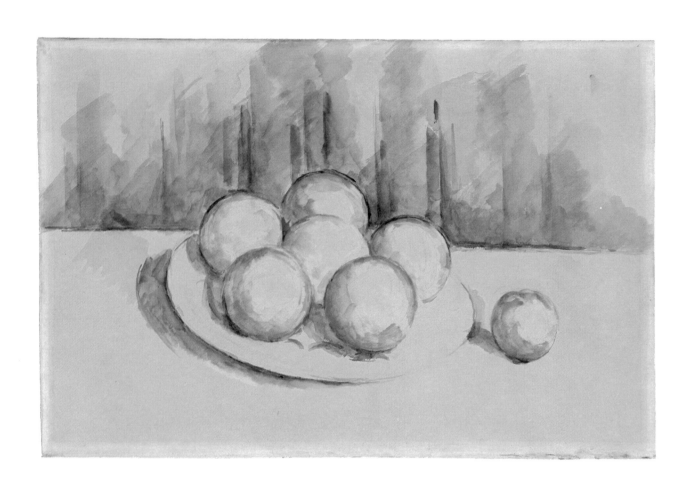

35. AIX CATHEDRAL, VIEW FROM THE STUDIO AT LES LAUVES, 1902–4
(La Cathédrale d'Aix, Vue de l'Atelier des Lauves)

GRAPHITE AND WATERCOLOR ON WHITE WOVE PAPER

WATERMARK: MONTGOLFIER/SAINT/MARCEL/LES/ANNONAY

12½ x 18¾" (31.7 x 47.6 CM.)

PHILADELPHIA MUSEUM OF ART. THE LOUISE AND WALTER ARENSBERG COLLECTION

50-134-AI-35

35a. *View of Aix from Les Lauves*
Photograph by John Rewald

35b. Paul Cézanne
*The Cathedral of Aix Seen from the Studio at
Les Lauves*
Pencil and watercolor, 12½ x 18½"
The Alex Hillman Family Foundation,
New York

THIS LANDSCAPE aligns quite closely with that in a photograph showing the view across the city of Aix from Cézanne's studio at Les Lauves, with the double-tiered tower of the cathedral of Saint Sauveur on the left (fig. 35a). However, as so often occurs in these remarkable comparisons between the actual motif and Cézanne's treatment of it, one is struck more by his great freedom in working it through his eye and mind than by the literal rendering of the view. The cathedral and the range of mountains beyond are certainly recorded here, but the great sweep of space and animated air are evoked in a way that far surpasses the powers of photography. Swift strokes of the pencil establish the essential forms, to which are added in a very spare manner, washes of light green, blue, lavender, and yellow. These are applied in beautiful cursive licks with an even lightness from the bottom to the top of the sheet, giving an overall effect of almost crystalline clarity.

It has sometimes been assumed that the very gentleness of the color here is due to fading pigments. In fact, although the paper has slightly yellowed, the effect is probably quite true to the watercolor when it was fresh. The almost glacial delicacy and restraint of color—as if done on a particularly clear winter's day—is striking when compared to another view of the cathedral (fig. 35b; Venturi 1077), which while retaining the same deliberate, even application of washes, is much more dense, as if, by contrast, it had been done in the summer.

PROVENANCE: Marius de Zayas, New York?; Louise and Walter Arensberg, New York and Hollywood, Calif.; Philadelphia Museum of Art, 1950

EXHIBITIONS: Oakland, Calif., Mills College Art Gallery, *European Master Drawings of the Nineteenth and Twentieth Centuries* (February 19–March 29, 1939), no. 13; Chicago, The Art Institute of Chicago, *20th Century Art. From the Louise and Walter Arensberg Collection* (October 20–December 18, 1949), p. 36, no. 39; New York, Solomon R. Guggenheim Museum, *Paintings from the Arensberg and Gallatin Collections of the Philadelphia Museum of Art* (1961); Pasadena, Calif., Pasadena Art Museum, *Cézanne Watercolors* (November 10–December 10, 1967), p. 54, no. 36

BIBLIOGRAPHY: Philadelphia, PMA, *The Louise and Walter Arensberg Collection: 20th Century Section* (Philadelphia, 1954), no. 34; New York, 1977, p. 296, pl. 98; Francis Naumann, "Walter Conrad Arensberg: Poet, Patron, and Participant in the New York Avant-Garde, 1915–20," *Philadelphia Museum of Art Bulletin,* vol. 76, no. 328 (Spring 1980), p. 10, fig. 9, no. 30; Rewald, 1983, no. 581

36. RECTO: *MONT SAINTE-VICTOIRE SEEN FROM LES LAUVES,* 1902–6
(La Montagne Sainte-Victoire, Vue des Lauves)

GRAPHITE AND WATERCOLOR ON WHITE WOVE PAPER
18½ x 12⅜″ (47 x 31.4 CM.)

VERSO: *FORKED TREE,* 1900–1906
(Arbre Fourchu)

GRAPHITE AND WATERCOLOR ON WHITE WOVE PAPER
18½ x 12⅜″ (47 x 31.4 CM.)
PRIVATE COLLECTION

RECTO

THIS VERTICAL Mont Sainte-Victoire relates closely to an oil painting of the same proportions[1] and allows Cézanne through the restriction of horizontal elements to create a view of penetrating depth and perspective. The lyrical curves of the almond trees in the foreground establish a swiftness of rhythms that moves through the isolated washes of the middle ground to the mountain beyond. Yet the degree of control, within all this joyous evocation of grand space and air, is disconcertingly bold and effective. The brilliant greens and blues balanced against the white paper move into the sky, where on the left a rich wash of green unifies the top of the sheet with the foreground, abandoning literal rationality for a unifying and expansive harmony.

The curious image of a forked tree on the reverse is done without the assistance of pencil drawing, the strong red washes giving it a particularly haunting quality despite the relative slightness of the image.

NOTE:
1. New York, 1977, p. 310, pl. 117, pp. 403–4, cat. no. 57.

PROVENANCE: Ambroise Vollard, Paris; Feilchenfeldt, Zurich; Otto Wertheimer, Paris; Wildenstein Galleries, New York; Helen R. Tyson, Philadelphia; Estate of Helen R. Tyson, Philadelphia; Private collection, Philadelphia

EXHIBITIONS: London, Galerie Paul Cassirer, *Paul Cézanne Watercolours* (1939), no. 28; London, Arts Council of Great Britain, *Paul Cézanne: An Exhibition of Water Colours* (1946), no. 57; New York, 1977, p. 311, pl. 118, p. 413, cat. no. 107; Paris, 1978, p. 204, no. 88

BIBLIOGRAPHY: Rewald, 1983, no. 588

VERSO

PRINTS

CÉZANNE'S INTEREST in prints was limited. His first experiments were a group of etchings he did in 1873 at the encouragement of his host at Auvers, the amiable Doctor Gachet, and with the assistance of others. There is a charming drawing (Chappuis 292) showing the two men intensely working over an etching plate, preparing it for the acid bath before a table littered with bottles of chemicals. This nicely documents the air of amateur enthusiasm that must have pervaded these sessions. Of the five etchings that survive from this period (*see* no. 1 for one etching project never carried out), three are exhibited here. The two others are a view of *Fishing Boats on the Seine at Bercy*,[1] which exists in very few impressions, inscribed as being after a painting by Guillaumin; and a landscape recording a sketching outing entitled *A View of a Garden, Bicêtre*,[2] of which there is a unique impression at the Bibliothèque Nationale in Paris. Cézanne seems never to have returned to etching after this time.

His second encounter with printmaking was on a more ambitious and commercial level. Beginning in the second half of the 1890s, Cézanne participated in the execution of three lithographs, including *The Large Bathers*, his one masterpiece in this medium, commissioned by his dealer, Ambroise Vollard, who gave him his first major exhibition in 1895. All are represented here in various versions.

NOTES:
1. Paris, Bibliothèque Nationale, *L'Estampe impressionniste* (Paris, 1974), p. 133, no. 278.
2. *Ibid.*, p. 132, no. 281.

37. GUILLAUMIN HANGED, 1873
(Guillaumin au Pendu)

ETCHING

9⅞ x 6⅜" (25.1 x 16.2 CM.)

PRIVATE COLLECTION

THE TITLE *Guillaumin Hanged* is a triple visual pun: Cézanne's friend and fellow participant in the exploration of etching at Auvers in the summer and fall of 1873 is shown casually seated before a sketch of a hanged man, itself hung by a nail on the wall. The reference probably also extends to a landscape painting, perhaps his most successful during the Auvers period, of the house in the village known as the *House of the Hanged Man* (Venturi 133).

Guillaumin, Pissarro, and Cézanne were all drawn into printmaking by their enthusiastic host, Doctor Gachet, who was himself an amateur printmaker, under the pseudonym of Van Ryssel. He had a press in his house, where Cézanne was living at the time, and encouraged his companions to transfer their sketches onto the plate probably as much for private amusement as for anything else, although Pissarro, unlike Cézanne and Guillaumin, would continue to work seriously in this medium.

As Michel Melot points out,[1] the very casualness of this pleasing image, as well as the rather awkward working of the etching needle, may indicate that this was the first of Cézanne's five efforts in etching. While very few impressions were made originally, the plate still survives and later restrikes of this print are now widespread.

NOTE:

1. Paris, Bibliothèque Nationale, *L'Estampe impressionniste* (Paris, 1974), p. 131, no. 277.

PROVENANCE: Marguerite Cunliffe, Saint Petersburg, Fla.; Maurice Blackburn, Philadelphia; Private collection, Philadelphia

BIBLIOGRAPHY: *L'Amour de l'Art* (1921), p. 29; Gustave Coquiot, *Paul Cézanne* (Paris, 1919), p. 62; Venturi, 1936, vol. 1, p. 288, no. 1159, vol. 2, pl. 332, no. 1159; Gachet, 1952, no. 2; Cherpin, 1972, no. 2; Paris, Bibliothèque Nationale, *L'Estampe impressionniste* (Paris, 1974), p. 131, no. 277

38. HEAD OF A YOUNG WOMAN, 1873
(Tête de Jeune Fille)

ETCHING

12⅝ x 9¹⁄₁₆" (32.1 x 23 CM.)

PHILADELPHIA MUSEUM OF ART

THE MUSEUM'S impression of this print is bound as the frontispiece to a 1914 edition of Ambroise Vollard's biography of Cézanne,[1] which was published in an edition of one thousand. The plate continued to exist for quite some time and impressions of it are abundant.

Of the five etchings Cézanne executed while staying with Doctor Gachet, this is both the most successful and the most revealing. The needle drawing is done with great abandon and the plate is bitten very deeply. It suggests all the experimental vigor with which these prints were undertaken, and it is really most remarkable (and a credit to Cézanne's power as a draftsman if not as a printmaker) that the image of this young woman persists so effectively through the execution.

NOTE:

1. Vollard, 1914.

PROVENANCE: Christian Brinton, Philadelphia; Philadelphia Museum of Art, by bequest

BIBLIOGRAPHY: Gustave Coquiot, *Paul Cézanne* (Paris, 1919), p. 62; Venturi, 1936, vol. 1, p. 288, no. 1160, vol. 2, pl. 332, no. 1160; Gachet, 1952, no. 4; Cherpin, 1972, no. 6; Paris, Bibliothèque Nationale, *L'Estampe impressionniste* (Paris, 1974), p. 132, no. 279

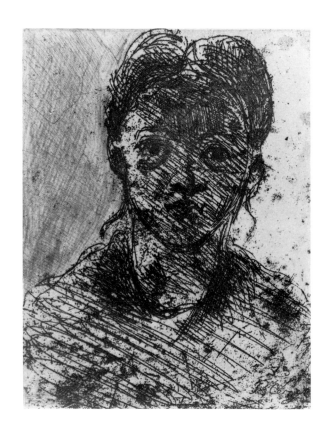

39. *LANDSCAPE AT AUVERS, 1873*
(Paysage à Auvers)

ETCHING
14⁹⁄₁₆ x 11″ (37 x 27.9 CM.)
PHILADELPHIA MUSEUM OF ART. GIFT OF THE PRINT CLUB
46-35-18

THIS IS the only etching by Cézanne that relates directly to one of his own paintings, a view of an entrance into a farm on the rue Saint-Remy (Venturi 139), which he eventually gave to Pissarro. The Museum's impression of this print appears to be quite an early one. The edges of the lines are still fresh and the plate is subtly inked. Later impressions were used by Gaston Bernheim-Jeune as a frontispiece to his 1914 book on Cézanne.[1]

NOTE:
1. Gaston Bernheim-Jeune et al., *Cézanne* (Paris, 1914).

PROVENANCE: Roger Marx, Paris; Print Club, Philadelphia; Philadelphia Museum of Art, by gift, 1946

BIBLIOGRAPHY: Gustave Coquiot, *Paul Cézanne* (Paris, 1919), p. 62; Venturi, 1936, vol. 1, p. 288, no. 1161, vol. 2, pl. 332, no. 1161; Gachet, 1952, no. 5; Cherpin, 1972, no. 5; Paris, Bibliothèque Nationale, *L'Estampe impressionniste* (Paris, 1974), p. 132, no. 280

40. *SELF-PORTRAIT*, 1896–97
(Portrait de Cézanne)

LITHOGRAPH
12¾ x 10⅞″ (32.4 x 27.6 CM.)
PHILADELPHIA MUSEUM OF ART. PURCHASED: JOHN D. McILHENNY FUND
41-8-27

PROVENANCE: Philadelphia Museum of Art, purchased, 1941

BIBLIOGRAPHY: Vollard, 1914, repro. p. 90; Venturi, 1936, vol. 1, p. 287, no. 1158, vol. 2, pl. 332, no. 1158; Druick, 1972, p. 15, nos. 11–12; Druick, 1977, pp. 123–24, figs. 9, 4

NOTES:
1. Druick, 1977, pp. 128–29.
2. *Ibid.,* p. 126.

IN THE 1890S, Ambroise Vollard persuaded Cézanne to execute three lithographs, this and the following two. As Druick persuasively argues, the dealer's intentions were a combination of entrepreneurism and a genuine desire to broadcast the ability of the still little-known artist through a reproductive medium, executed by his lithographer, Auguste Clot, with extremely high technical standards.[1]

Cézanne, who had shown no interest in printmaking since his few efforts at the encouragement of Doctor Gachet in 1873, was persuaded not only to allow certain of his works to be taken up in this medium but also to actually participate in the project. Lithography, then undergoing new investigations of color printing possibilities, seemed the ideal medium for this work.

Vollard encouraged the artist to do a self-portrait. While somewhat close to the painted *Self-Portrait with a Beret* in Boston (Venturi 693), here a large sketch pad is introduced. As Druick points out, the image was probably transferred to the stone by the master-printer Clot from a drawing on transfer paper done by Cézanne.[2] This explains the granular texture of the lines and the somewhat flattened quality of the overall image. This print does not seem to have gone beyond the proof state in Cézanne's lifetime. The first edition, of one hundred, was pulled in 1914; a second edition, of the same number, was made in 1920.

41. *THE LARGE BATHERS,* c. 1898
(Les Grands Baigneurs)

LITHOGRAPH

16⅛ x 19¾″ (41 x 50.2 CM.)

PHILADELPHIA MUSEUM OF ART. PURCHASED: JOHN D. McILHENNY FUND

41-8-26

42. *THE LARGE BATHERS,* c. 1898
(Les Grands Baigneurs)

COLOR LITHOGRAPH

16⅛ x 19⅞″ (41 x 50.5 CM.)

PHILADELPHIA MUSEUM OF ART. THE LOUISE AND WALTER ARENSBERG COLLECTION

50-134-C-874

PROVENANCE: Louise and Walter Arensberg, New
York and Hollywood, Calif.; Philadelphia Museum
of Art, 1950

43. *THE LARGE BATHERS,* c. 1898
(Les Grands Baigneurs)

COLOR LITHOGRAPH

16 x 19⅞″ (40.6 x 50.5 CM.)

PRIVATE COLLECTION

(NOT ILLUSTRATED)

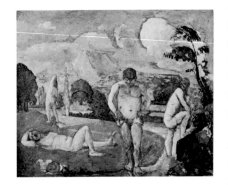

42a. Paul Cézanne
Bathers at Rest, 1875–76
Oil on canvas, 31¼ x 38¾″
© Barnes Foundation, Merion, Pa.

THIS LITHOGRAPH is drawn after what was, in the 1890s, one of Cézanne's most famous works, *Bathers at Rest* (Venturi 276), now in the Barnes Foundation. The painting had received much comment, mostly derisive, when it was shown in the third Impressionist exhibition in 1877. With the four male figures in a vast space before Mont Sainte-Victoire, it was the artist's most ambitious dealing with this subject before he returned to it on a grand scale in the 1890s. The color of the painting is particularly brilliant, with bold ultramarine and chartreuse set against intense greens and orange. It was perhaps for this reason that Cézanne chose it when Vollard commissioned him to produce lithographs in the 1890s. It has been suggested that the notoriety the painting received by having been among those works from the Caillebotte bequest rejected by the state could not have gone unnoticed by Vollard, who featured it in the window of his shop in 1895.[1] However, as Druick points out, it is likely that the preparation for the print preceded the opening of the new galleries at the Musée du Luxembourg, which housed the donation.[2] Be this as it may, this was the most successful of Vollard's lithographic endeavors with Cézanne and, despite its immediate dependency on a painting, stands as a substantial work of art in its own right; the suggestion that it is a reproductive work misconstrues Cézanne's (and perhaps even Vollard's) participation in these projects.

The black and white version of this print (no. 41) was prepared by Auguste Clot from a transfer drawing made by the artist. Druick observes that the drawing is somewhat more tentative than in the original painting, which may indicate Cézanne's unfamiliarity with the lithographic process but which might also reflect the hesitancy of this painfully shy and by then nearly reclusive figure to broadcast his work in a medium which, by its very nature, would be circulated broadly.[3] This impression was pulled in an edition of one hundred.

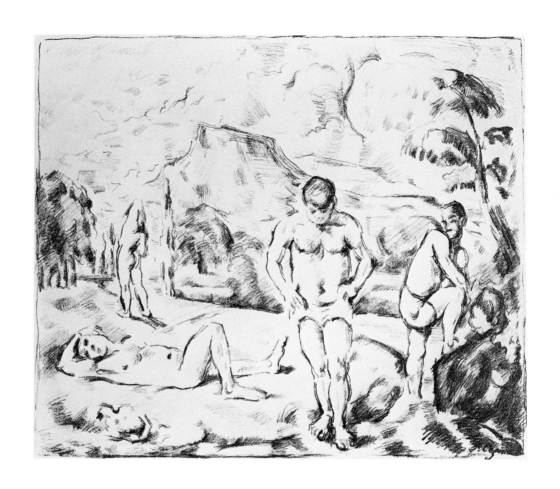

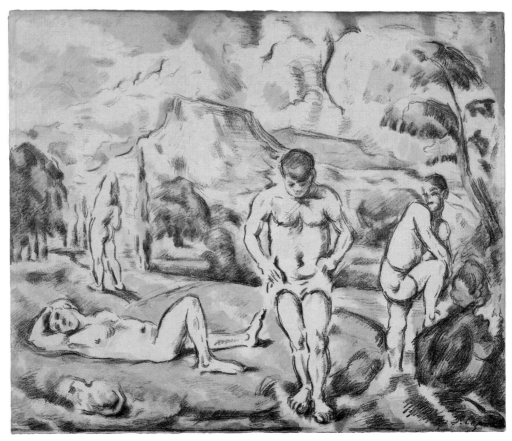

Following the black and white edition, Cézanne, working closely with the printer, began to experiment with the addition of color by using impressions of the black and white print as his maquette and working over it in watercolor. The National Gallery of Canada in Ottawa has a maquette that belonged to Vollard, although it is possible that the artist, experimenting with various tones and effects, did several watercolor versions on the black and white print. From these, six color stones were prepared—ocher, blue, green, yellow, red, orange—for the laborious and careful printing of the colored version. This was printed in two editions: the first, marked "Tirage à cent exemplaires" and signed, was probably printed in 1898 (no. 43); the second, from a new set of stones omitting the orange one, bore only the signature and was probably printed in 1914 (no. 42). In all editions there is considerable variation in color; this represents constant experimentation on the part of the printer to adjust the stones and to improve the image, and suggests the very high standards of both the artist and Vollard in this medium.

NOTES:
1. *See* Melvin Waldfogel, "Caillebotte, Vollard and Cézanne's 'Baigneurs au Repos,'" *Gazette des Beaux-Arts,* 107th year, 6th ser., vol. 65 (1965), p. 114.
2. Druick, 1972, p. 20.
3. Druick, 1977, p. 127.

PROVENANCE: Weyhe Gallery, New York

BIBLIOGRAPHY: Venturi, 1936, vol. 1, p. 287, no. 1157, vol. 2, pl. 332, no. 1157; Melvin Waldfogel, "Caillebotte, Vollard and Cézanne's 'Baigneurs au Repos,'" *Gazette des Beaux-Arts,* 107th year, 6th ser., vol. 65 (1965), p. 114, fig. 1; Druick, 1972, pp. 4–5, figs. 2–3, pp. 8–9, figs. 4–6, p. 13, fig. 10, p. 17, fig. 13; Druick, 1977, pp. 124–25, figs. 3, 7, pp. 132–33, figs. 10–12

44. *SMALL BATHERS,* 1896–97
(Baigneurs)

COLOR LITHOGRAPH
9⅛ x 11⁵⁄₁₆″ (23.2 x 28.7 CM.)
PHILADELPHIA MUSEUM OF ART. BEQUEST OF FISKE AND MARIE KIMBALL
55-86-44

THIS IMAGE closely relates to a series of male bathers that Cézanne was working on in the 1890s (*see* no. 19), although it follows none so directly as does the more ambitious *Large Bathers* (nos. 41–43). Cézanne seems to have drawn the image directly on the stone (as opposed to his two other lithographs, which were probably transferred from lithograph paper by Clot) and at least ten impressions exist in black and white before the addition of color. According to Druick, through the direct drawing on the stone and the necessity to reverse the image, this was the most complicated of the prints for the artist himself; he therefore dates it last in the series, after Cézanne had gained some confidence with this unfamiliar medium.[1]

The color version was first published by Vollard in 1897; this print is from the second edition (in which the signature was removed), for which new color stones were prepared. It was probably printed in an edition of one hundred after the artist's death.

NOTE:
1. Druick, 1977, p. 127.

PROVENANCE: Fiske and Marie Kimball, Philadelphia; Philadelphia Museum of Art, by bequest, 1955

EXHIBITION: Philadelphia, 1934, no. 58

BIBLIOGRAPHY: Vollard, 1914, repro. p. 87; Venturi, 1936, vol. 1, p. 287, no. 1156, vol. 2, pl. 332, no. 1156; Druick, 1972, pp. 11–13, nos. 7–9; Druick, 1977, pp. 124–25, figs. 5–6, p. 129, fig. 8